D0772741

WATERCOLOR A Beginner's Guide

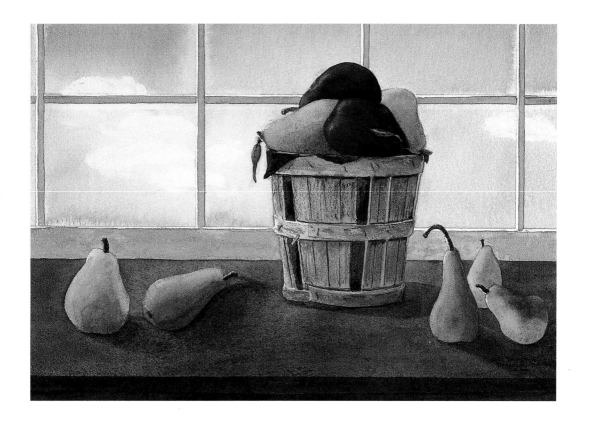

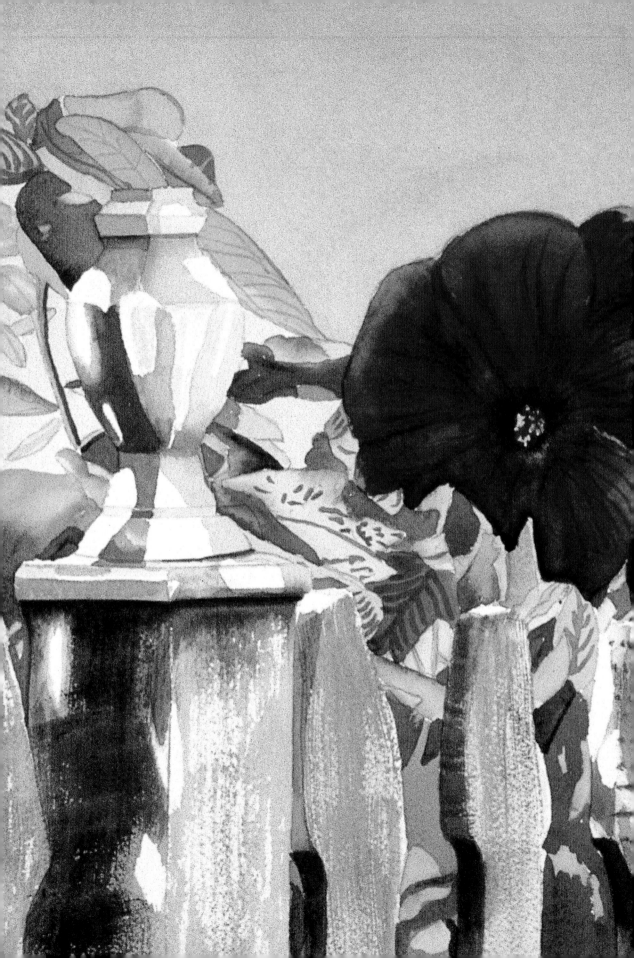

WATERCOLOR
A Beginner's Guide

Elizabeth Horowitz

WATSON-GUPTILL PUBLICATIONS/NEW YORK

ACKNOWLEDGMENTS

For her fine help, I thank Karen Reeds, Ph.D.
And to the dedicated team at Watson-Guptill Publications,
my thanks go to acquisitions editor Candace Raney,
project editor Robbie Capp, designer Areta Buk,
and production manager Ellen Greene.

Half-title page:
Elizabeth Horowitz
PECK OF PEARS
Watercolor on paper, 15 × 22″ (38 × 56 cm).

Title spread:
Elizabeth Horowitz
THE AMERICAN DREAM
Watercolor on paper, 12 × 16″ (31 × 41 cm).

Executive Editor: Candace Raney
Project Editor: Robbie Capp
Designer: Areta Buk
Senior Production Manager: Ellen Greene
Text set in 11-pt. Garamond

ILLUSTRATION CREDITS

Photograph of the author by Gary Abatelli; technique photographs
by Emily Jane Horowitz; reference photographs by the author.
All drawings and paintings by the author, unless otherwise identified.

Library of Congress Control Number 2209925018
ISBN: 978-0-8230-3300-3

Printed in Singapore

1 2 3 4 5 6 7 8 9 / 17 16 15 14 13 12 11 10 9

About the Author

ELIZABETH HOROWITZ has enjoyed a career as an accomplished watercolorist for more than two decades. She has many solo shows and distinguished awards to her credit, and her paintings hang in a number of museum, corporate, and private collections. A member of the New York Society of Illustrators, the Garden State Watercolor Society, and a teacher of art, Horowitz is known for her popular watercolor classes at the New Jersey Center for Visual Arts in Summit, New Jersey, and the Armory Art Center in West Palm Beach, Florida. Her work is currently represented by the Peterson Gallery in Santa Fe, New Mexico, and the Lenox Gallery of Fine Art in Lenox, Massachusetts. Poster reproductions of her watercolors are distributed widely by the Bentley Publishing Group. The author may be contacted by e-mail at: carriagehousestudio@earthlink.net.

Contents

Preface

Watercolor for the First Time is the direct result of my teaching experience. It is based on the methods I've employed in my classroom over many years. Students come to me with little or no art-school background and create outstanding paintings very quickly, while having fun doing it—which prompted me to write this book. I attribute that positive result to an attitude of *spielen,* a willingness to be playful and exploratory, without prejudging the outcome.

My teaching approach is to design exercises that make learning art fundamentals not a chore, but an enjoyable activity and gratifying means of personal and spiritual expression. And in these pages as well, my instruction encourages beginners to develop their individual style while learning all the art fundamentals needed to create wonderful watercolor paintings.

The first chapters cover watercolor materials, basic techniques, color, composition, and other fundamentals. Then the focus shifts to particular subject matter, with exercises for creating a painting in each chapter. Trees and skies, simple structures like barns, flowers, water, and other popular subjects are included. Although most "how-to" art books have step-by-step demonstrations for readers to mimic the artist-author's composition, palette, and brushwork as precisely as they can, this book features open-ended lessons. Each exercise begins with reference photos and directions for working with them. Composition, technique, and color suggestions are provided, then you are encouraged to make your own choices along the way for completing your painting, with a liberal number of tips offered as you proceed. For example, based on the

Elizabeth Horowitz
SHORE VIEW
Watercolor on paper, 18 × 24″ (46 × 61 cm).

techniques you've learned and practiced in earlier chapters, in succeeding chapters, you are able to select just the kind of techniques you'd like to use for the sky in your painting and which colors to blend for the foliage, and so on, to make your own personal statement.

At the end of each chapter, you are shown several interpretations of the same subject matter—a "Student Gallery" of paintings completed in my classroom studio. It's fascinating and very instructive to see how wide-ranging interpretations of the same subject can be—as different and personal as each individual's handwriting. The students' lives outside of the studio are as varied as their paintings. Reproductions of their work in these pages include creations by homemakers with children, retired business executives, and working women and men of various ages from the fields of architecture, chemistry, computers, engineering, law, psychiatry, and theology. The common denominator that drew them to the art studio is a passionate new love interest that they all share: the art of watercolor.

In class, I see myself more as an art "emancipator" than an art "educator." My goal is the same here, on the printed page. Teaching has enabled me to encapsulate what I have learned as a working artist and share a condensed version of it with beginners eager to see the world anew through the eyes of an artist, gaining a deeper appreciation of color, light and, of course, Mother Nature. I hope that my love and enthusiasm for painting will be contagious, and that you, too, will blossom into a committed watercolor artist.

Happy painting!

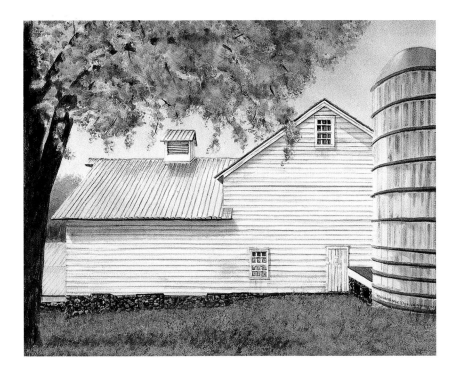

Elizabeth Horowitz
NOVEMBER'S NOLLE
Watercolor on paper, 12 × 16" (31 × 41 cm).

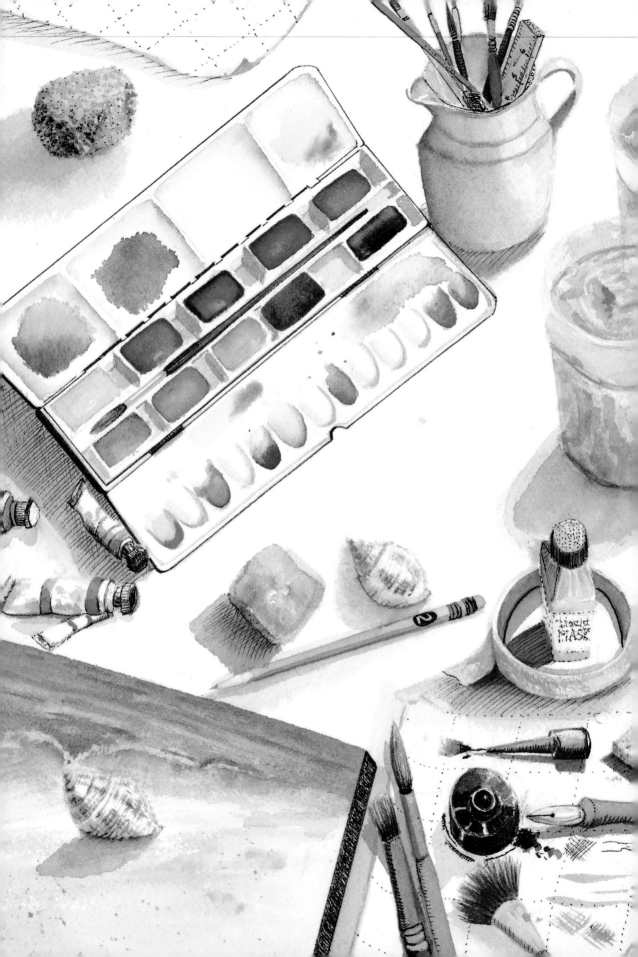

Materials

Today's watercolorists are heirs to a long history in the development of art and art materials. In prehistoric times, the world's first artists used charcoal to draw on cave walls. Thousands of years later, the Egyptians colored their art by crushing insects to get a reddish pigment and grinding semi-precious stones such as lapis lazuli to get blue pigment and malachite for green.

When Renaissance masters expanded their palettes, they ground pigments with linseed oil to formulate oil paints. Centuries later, paints were revolutionized in Paris of the mid-1800s with the invention of the lead tube. Artists no longer needed to go through the time-consuming process of buying chemicals from an apothecary and grinding them to make paint; pigments could be purchased prepackaged in tubes. The great French Impressionists were then able to take their palettes out of their studios and paint *en plein air,* the portability of materials enabling them to paint directly from nature. Attempting to capture changing light and weather forced artists to observe and paint quickly, which brought on a new style of painting filled with energy and spontaneity.

Along with the development of portable materials, the Impressionists took watercolor to new levels, where it was no longer just a preliminary study or field sketch for an oil painting. It was John Singer Sargent who elevated the status of watercolor to a work of art on paper. I encourage you to study his work, along with paintings by other master watercolorists: Winslow Homer, Paul Cézanne, Maurice Prendergast, John Marin, Georgia O'Keeffe, and Andrew Wyeth. In their work you will see the brilliance and diversity of art that can be achieved with the exciting medium of watercolor.

In addition to paint, other basic materials that you will need are summarized in a concise list at the end of this chapter. But before you assemble your materials, we begin with an overview of the basics: paint, paper, and brushes.

Elizabeth Horowitz
THE ARTIST'S TABLE
Watercolor on paper,
12 × 9″ (31 × 23 cm).

Paint

Of all forms of artist's paints, water-color is considered the purest, as it contains the most pigment and the fewest additives, hence its ability to create luminescence.

Each color has unique painting properties: transparency, opacity, permanence, staining ability, or granu-lation. It's important to know which colors fall into which category (and some fall into more than one), to help you choose the right ones for the effects you want to achieve.

TRANSPARENT COLORS allow the white of the paper to show through. The yellows: transparent yellow, cadmium yellow deep, gamboge, aureolin. Greens: sap green, Hooker's, terre verte, oxide of chromium, viridian, olive. Blues: cobalt, ultramarine, manganese, phthalo. Reds, purples: alizarin crimson, purple madder, cobalt violet, rose doré, scarlet lake, permanent rose, magenta, perma-nent mauve. Others: raw sienna, raw umber, burnt sienna, burnt umber, brown madder.

OPAQUE COLORS can't be seen through. The reds: cadmium, vermillion, Indian red. Yellows: cadmium, cadmium lemon, yellow ochre, Naples yellow. Greens: cobalt, emerald. Blues: cerulean, cobalt turquoise, indigo. Others: sepia, Payne's gray, Davy's gray, blue black, ivory black.

PERMANENT/STAINING COLORS discolor the paper and cannot be lifted from it. Reds, purples: alizarin crimson, cadmium red, vermillion, permanent rose, Venetian red, purple madder,

violet. Yellows: aureolin, gamboge, cadmium yellow. Greens: sap green, Hooker's, olive, viridian. Blues: phthalo blue, indigo. Others: neutral tint, Payne's gray, brown madder.

NONSTAINING COLORS can be lifted from the paper or lightened. Reds: rose

Tube watercolors come in 5-ml and 14-ml tubes. I recommend the smaller tubes for starters. Later, you may want to invest in larger tubes of colors that become your favorites. Tube watercolors are fluid; pan watercolors are small, hard cakes that come in sets, useful for small works and painting on the go, but they may wear out good brushes quickly. Tube paints, being liquid, are easier to mix. Popular brands include Schmincke, Sennelier, Winsor & Newton, Holbein, and Grumbacher. Most offer both professional-quality and lower-priced student-grade tube watercolors. Better paint equals better coverage, vibrancy, and light-fastness, which guards against colors fading over time. However, as a beginner, if you want to limit your investment, student-grade paints can serve you well. With experience will come a reverence for higher-quality paints when you try them later.

madder. Yellows: translucent yellow. Greens: terre verte. Blues: cerulean, cobalt, ultramarine, cobalt turquoise. Others: burnt sienna, sepia, Davy's gray.

GRANULAR COLORS appear mottled and grainy. They sink into the valleys of watercolor paper, revealing its surface

texture. Reds: cadmium, cadmium red deep, rose madder. Blues: manganese, cerulean, cobalt, French ultramarine. Violets: ultramarine, cobalt, mauve. Yellows: yellow ochre. Greens: cobalt, viridian, oxide of chromium. Other: raw sienna, burnt sienna, raw umber, burnt umber, sepia, ivory black.

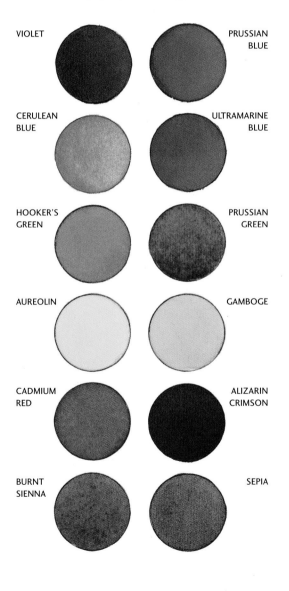

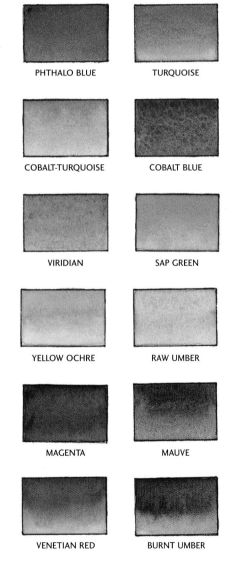

I recommend these twelve basic colors for starters.

When you want to expand your palette, these twelve, each shown in gentle gradations, are good additions.

Paper

Some terms that you're likely to find when shopping for watercolor paper are *archival* and *PH neutral,* which refer to the paper's ability to last over a long time without crumbling or yellowing. *Sizing* refers to a chemical added to control the paper's absorbency. Without sizing, the paper would behave like a blotter, completely absorbing paint without holding sharp edges. However, if papers have excessive sizing, it can cause *crazing*—tiny white dots that appear after pigment has dried ("No, it is not a pigment of your imagination!" I tell students.) Putting more color and less water on the brush helps avoid crazing. Always remember: *Less water equals more control.*

Paper Forms, Sizes

The most expensive papers are made by hand, often with appealing uneven, deckled edges. But many fine, less costly papers are widely available for your use, sold in sheets, blocks, pads, and rolls. Sheets and blocks are good choices. Popular brands to consider include Arches, Winsor & Newton, and Fabriano.

WATERCOLOR SHEETS come in three sizes: full sheets, 22 × 30"; half sheets, 15 × 22"; quarter sheets, 9 × 12". Begin on 9 × 12" before working larger. But beware of always painting on too small a sheet, which may lead to a tight, overworked style. On the other hand, before taking on very large sheets, you should be sure your technique is under control.

WATERCOLOR BLOCKS are bound on all four sides into a rigid block of about twenty sheets. In several sizes, start with 9 × 12". Blocks eliminate the need for mounting paper on a board to keep it flat. You paint on the top sheet of the block, and when your picture is dry, remove it, using a butter knife, letter opener, or other blunt blade. A small opening along one of the block's edges is where you insert the knife, then work around all four sides until the sheet is free.

Textures, Weights

Watercolor paper comes in three surface textures and several weights, which refer to the paper's thickness.

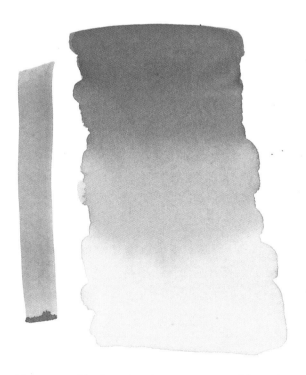

Hot-pressed is the smoothest paper, good for detailed work.

HOT-PRESSED PAPER has the smoothest surface of any watercolor paper, so it's most difficult to achieve textured effects on it. Painted edges stay very crisp and colors are vivid.

COLD-PRESSED PAPER—which I use mostly—usually recommended to my students and suggested for you—has a middle-of-the-road surface, not too smooth, not too rough. It lends itself to most watercolor techniques, and gives the painter the most flexibility.

ROUGH PAPER has an uneven surface and reveals the most texture in a painting. The brush glides over the hills of the paper's "tooth" without settling in the valleys, or crevices, as easily, making it suited to broad strokes and minimal detail.

140-LB PAPER is best for starters, but as you progress, experiment with other papers to explore their full potential. Paper weight is calculated by the weight of a ream of paper; the higher the number, the heavier and more expensive the paper. Avoid lighter-weight paper (90-lb), because it's harder to control a watery wash from flooding and puckering its surface. Heavier paper (300-lb) is best saved for advanced work.

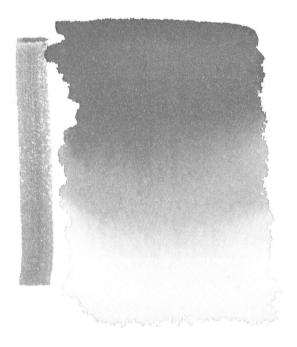

Cold-pressed paper, with its medium texture, is most versatile.

Rough paper is for highly textured work lacking fine detail.

Brushes

Watercolor brushes come in many shapes. For beginners, I recommend only two basic types, rounds and flats, but later on, experiment with others depicted here to see the many different effects to be achieved with them. It will help you develop a strong visual vocabulary in your brushwork.

The finest watercolor brushes are made of sable. Among those, the Russian kolinsky sable is the finest and most expensive brush. Its hairs are taken from the sable's underbelly in February, when the coat is thickest for winter. Those hairs hold the most water and have the strongest ability to spring back to their original shape and good point.

Synthetic brushes (of man-made fibers) are cheaper, stiffer, hold less water, and have less spring action. Although they tend to last longer, they rarely deliver the same quality point. Most art-supply stores will let you test a brush before buying it, by dipping it in water to remove the starch, to see if it resumes its original point or shape. If it collapses, make a new selection.

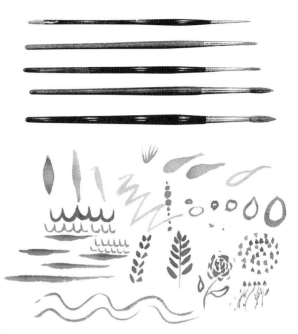

Round brushes are the most basic and useful of watercolor tools, producing the varied brushstrokes shown. Sizes in most brands range from No. 000, the smallest, up to about No. 12, the largest. No. 2 and No. 6 are your basics. Try to purchase a sable if your budget permits. With brushes, you get what you pay for. A sable will earn its keep by lowering the frustration you might feel when lesser-quality brushes don't produce the effects you're after.

BASIC SUPPLY LIST

In addition to materials just reviewed, this list includes other items that will be discussed in chapters ahead.

- 12 tube (5 ml) watercolor paints (per "Basic Colors" chart, page 13)
- 1 each brushes: Nos. 2 and 6 round; 1/2" flat
- 140-lb, 9-x-12" cold-pressed watercolor paper:12 sheets or watercolor block
- 2 large, wide-mouth water jars
- white plastic watercolor palette with lid
- spray water container
- liquid mask and toothpick or wooden skewer
- sketch and scrap paper
- No. 2B pencil
- indelible black-ink pen
- kneaded eraser
- rubber-cement pickup eraser
- natural sponge (not synthetic kitchen sponge)
- paper towels
- roll of 1" masking tape

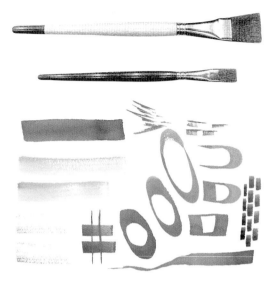

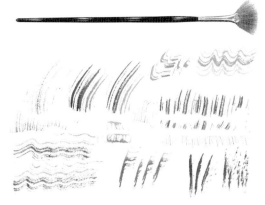

Flat brushes vary in size by fractions up to 3". The sampler above was made with the most useful size, the ¹/₂", which yields good square and rectangular strokes. When turned on its side, it creates thin strokes. The wide, flat strokes are also good for glazing wet color over dry color in a painting.

Fan brushes are used for blending, and are also great for depicting grass. A common trick is to trim the bristles unevenly to create irregular strokes, which appear more natural.

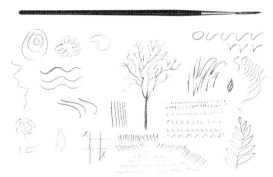

Mop brushes do just that—mop up lots of water when you've put too much down on your paper. Very soft, they are also great for blending.

Rigger brushes are for painting long, fine lines as in the upper branches of a tree, delicate foliage, stripes, or hair.

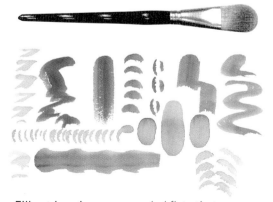

Hake (pronounced hock-ee) **brushes** are used for laying in large washes. Professional artists who stretch their own paper (to remove excess sizing) use these large, flat brushes, which are very soft and hold lots of water.

Filbert brushes are rounded flats that are great for blending and creating the nice fat strokes shown.

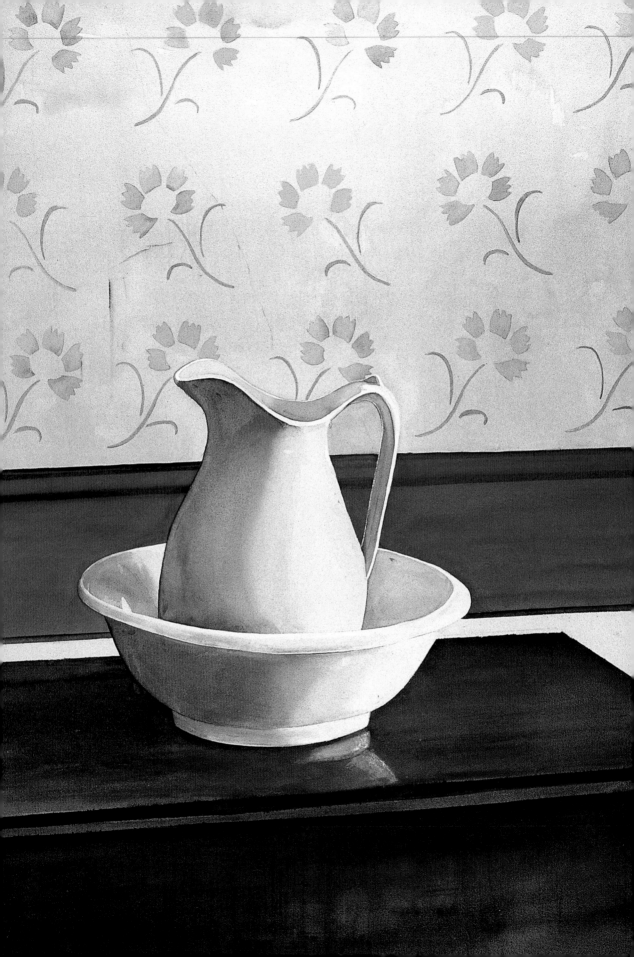

Setup

If possible, find a place where your watercolor supplies can be set up without having to move them when you're finished for the day. Then, whenever you can grab the time, you'll get right to the enjoyment of painting, instead of wasting time organizing your work space.

Your basic setup should include a table, a good light, and a comfortable chair or stool. Comfort is key. Some artists prefer to sit, while others like to paint standing up. Minimizing cleanup also affects your comfort level, so if you're working on carpet, throw down a drop cloth to protect the area where paint might spill or splatter. Keep a wastebasket nearby for those dirty paper towels you'll use for wiping and cleaning your brushes.

As for a work surface, although many "Sunday painters" use the kitchen table as their studio, if your budget and living space permit, consider purchasing a drawing table, frequently offered at sale prices by art-supply stores and online catalogs. Most drawing tables are adjustable. For watercolor painting, it should be set at a 30-degree angle. Otherwise, the paint will pool into flat puddles instead of flowing as it should. If you work on your kitchen table or other flat surface, you need to prop your paper up to that 30-degree angle. With a watercolor block, simply prop it up on a thick book or roll of paper towels. If you use an individual sheet of paper, secure it with masking tape to a board that you prop up in the same way. You'll need additional table space for your palette, brushes, water jars, and other supplies, placed within arm's reach to the right or left, depending, of course, on which hand you work with.

What about lighting? Even if you have sunshine streaming through a window, daylight changes more rapidly than a painting can be finished, so I suggest you use artificial light that simulates daylight. General Electric has such a bulb called Reveal; Philips has one called Natural. Use a clip-on lamp on the edge of your table, or pull up a floor lamp with the special bulb in it, and you're all set! A natural-light bulb is also useful at night, giving even illumination, but check to see that your hand is not in shadow as you work.

Elizabeth Horowitz
**SHAKER PITCHER
AND BOWL**
Watercolor on paper,
40 × 30" (102 × 77 cm).

Table and Lighting

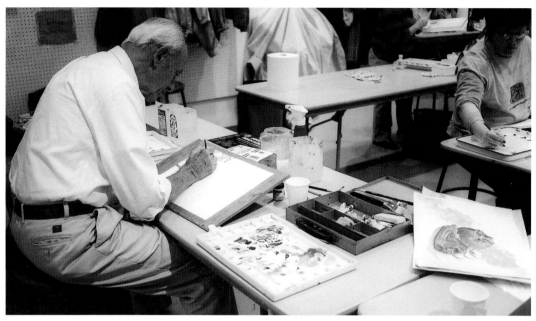

This student in my class at the New Jersey Center for Visual Art has his board propped up at a 30-degree angle so that his watercolor will flow properly, instead of pooling in puddles as it would on a flat surface.

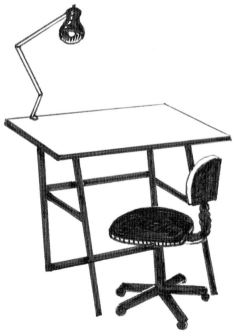

An adjustable drawing table set at an angle, a clip-on lamp with a bulb that simulates daylight, and a comfortable chair are three basics for a home studio.

Before recapping a tube, to avoid a later struggle reopening it, squeeze the upper sides of the tube to draw the paint back in. The paint should retract into the tube. But if it does clog up later, run the tube under hot water, grip it with a paper towel or pliers, and open the cap counterclockwise.

Setting Up Your Palette

It's important to choose a watercolor palette that's white, with about two-dozen deep wells for individual colors and a lid to use as a mixing area. A popular brand that fits that description is the John Pike palette. Economy-minded beginners may use an old white plate made of china or smooth, rigid plastic. But when you begin to work on larger sheets of paper, larger quantities of paint will be needed, which a plate won't hold as well.

In arranging colors on your palette, place them in an order that mimics the rainbow. Using a permanent, black marker pen with a fine point, label the palette's outside edge with the name of each color. Even professionals have trouble identifying each color by name, especially when the paint is dry. Label on the outside, not the inside mixing area, where your printing would eventually wear away, permanent marker or not. Squeeze out about a quarter-inch of paint from the bottom of the tube. Let your paint dry up in the palette without a cover or lid. (And never leave a wet sponge in a covered palette; it will encourage the growth of mold.) Unlike acrylic or oil paint, watercolor lasts for a long time on the palette, so even if it's dried up, don't toss it out! A spray of clean water will reactivate it beautifully.

PALETTE AND WATER TIPS

- After painting, clean your palette's mixing area so you'll be set to go next time.
- To save a large batch of color not used up in one session, mix and store the paint in a sterile baby-food jar or clear-plastic condiment cup.
- Use two water containers, each filled with at least two cups of water. Wide-mouth glass jars are ideal—except for travel or location work, where plastic jars are more practical.
- Put your brush in the first container to rinse, the second to clean. That way, you'll always have one jar of clean water, thereby avoiding extra trips to the sink.
- Once your palette is arranged, spray each color with a few squirts of water to activate the paint. For optimum color intensity, use distilled water. Boiled water is a good substitute.

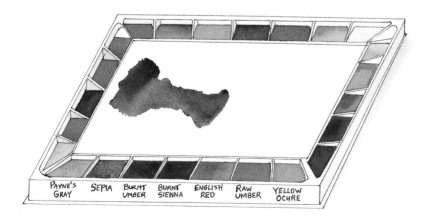

Set up your palette with colors arranged like a rainbow, followed by the earth tones. Label the colors in indelible ink on the outside edge of the palette. The center mixture is what I call the "Dynamic Duo"—ultramarine blue and burnt sienna, which makes a rich, gray-neutral tone.

PAYNE'S GRAY SEPIA BURNT UMBER BURNT SIENNA ENGLISH RED RAW UMBER YELLOW OCHRE

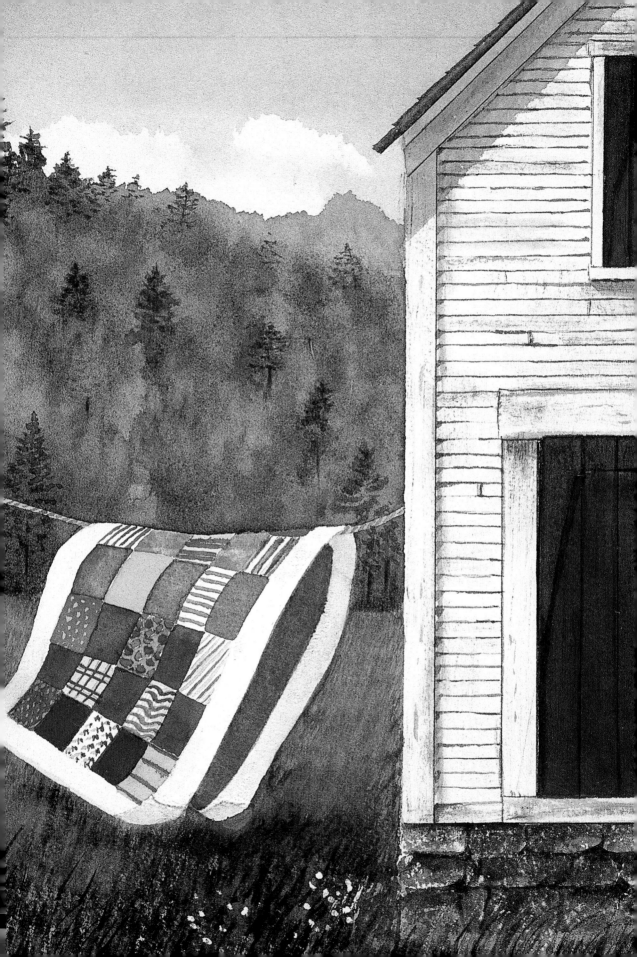

Basic Techniques

Painting in watercolor is like cooking from a recipe, except that there are no exact measurements, because the unique, inherent quality of watercolor paint is its very changeable nature. So you may find your paint doing unexpected things on your paper. If it does, perhaps because your paint flow isn't under control, it could turn out to be a happy accident. But if not, and that misplaced paint puts an unwanted purple banana in your picture, it will be hard to get rid of it. Few changes can be made in watercolor, so it's best to preplan and take an analytical approach from the start. This book takes that approach in teaching technique, aiming to free you from any fear of handling watercolor by keeping the process simple and enjoyable. Have fun, not frustration!

We begin with four indispensable techniques. An exercise for each will get you started practicing these basic ways to put watercolor on paper. But first, here's an overview of the four basic techniques.

A *flat wash* is used when you want a large area of the same value—that is, a solid color without any gradations of tone. For example, use a flat wash when painting a still life that has a background or flat wall with no gradation of tone, or change in value.

A *graded wash* modulates color from light to dark or dark to light. For instance, if light is falling on a vase in a still life, use a graded wash by painting one side in a light value and the other in a dark value to suggest the contours of the three-dimensional form.

The *drybrush* technique is used when texture is called for in a painting, such as on a tree trunk, weathered barn, wooden dock, or rocks. The effect of drybrush technique is accentuated on rough-surface watercolor paper.

A *wet-in-wet* wash, where edges flow and bleed together, works well as a background for florals or when you wish to work abstractly. It's also a good way to prestain or put a color "ground" on your paper or to paint skies.

Elizabeth Horowitz
BLOWIN' IN THE WIND
Watercolor on paper,
12 × 9″ (31 × 23 cm).

Exercise Preparation

Make sure you're working at a 30-degree angle. Unless you're using a watercolor block, secure your paper to a board with masking tape. Then:

- At the top of a 9-x-12" sheet of paper, draw four squares (each 2 × 2") and label them Flat Wash, Graded Wash, Drybrush, Wet-in-Wet.
- Below those, draw and number five smaller squares, labeled Pencil Values.

- Below those, draw five numbered squares (each 2 × 2"), labeled Paint Values.
- Squeeze two separate piles of Prussian blue on your palette and spray them with a few squirts of water. (Undiluted paint, straight from the tube, dries dull and ultimately cracks on paper.) The first pile is for techniques; reserve the second for values.

Exercise: FLAT WASH

STEP 1 Swivel your No. 6 round brush in paint until it is evenly loaded with color. If the paint glops up and looks like toothpaste, it's not well mixed.

STEP 2 Load your brush with paint as dark as you can make it and make one stroke in the top left (Flat Wash) square, using the brush tip. The paint should form a row of beads at the bottom of the stroke, where paint flowed because paper is propped up at a 30-degree angle.

STEP 3 Gather the beads of paint that formed at the bottom of the row and paint a second stroke across, from right to left. Reload your brush if needed. If you don't "stay in the lines," not to worry. This is just practice.

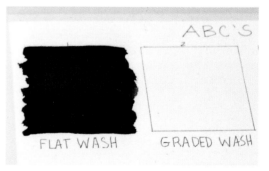

STEP 4 Continue working downward, alternating the direction of your strokes. Reload your brush with color as needed. Catch the beads of paint on each row until the square is filled. The finished Flat Wash square should not have variations in value; the tone should be the same dark blue throughout.

Exercise: GRADED WASH

STEPS 1, 2, 3, 4 Load your brush and paint a very dark stroke across the Graded Wash square, left to right. Dip the brush once in water, wiping excess water on the rim of the jar—*not* on a towel. Paint a stroke right to left, catching the bead from the bottom of the previous stroke. This stroke should be lighter than the first. Dip the brush twice in water, wipe again, and paint from left to right. Don't reload your brush with color. Dip in water three times, wipe, paint right to left. Each stroke should be lighter than the last. Swish the brush in water, wipe again, and make the final stroke. If it isn't very pale, blot (don't rub) with a paper towel to lighten. Your completed Graded Wash square should show a subtle gradation from very dark to very pale.

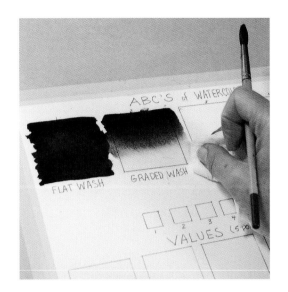

Exercise: DRYBRUSH

STEPS 1, 2, 3 Dip a dry 1/2" flat synthetic brush in blue paint with little water (synthetic, because drybrush can wear down sable bristles). The goal is to cover the hills of the paper's surface, not to flood into its valleys. Blot the brush on a paper towel. With pressure, push down on the belly (not tip) of the brush, and drag across the square, left to right. Paint back and forth, filling the square, without reloading the brush. White spots should show through, as though you're not getting good paint coverage.

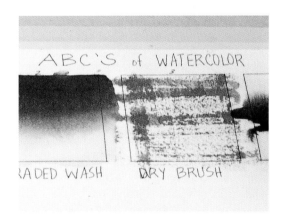

■ EXERCISE TIPS

- This book is a foundation course. Work sequentially, and try not to skip ahead until you're comfortable with each technique and exercise.
- Many students think they've mastered these exercises by doing them just once. Then they become frustrated later when they can't produce a particular technique for a certain painting. Avoid that roadblock by practicing on small squares first, then making them larger and larger until each technique becomes second nature. Then you'll always get the effects you want with ease.

Exercise: WET-IN-WET

STEPS 1, 2, 3 With only clean water (no paint) on your No. 6 round brush, cover the Wet-in-Wet square with water. Make sure the square is covered completely. As the paper soaks up water, the shine will go away. When it does, load your brush with blue paint and make a long, horizontal stroke, then a vertical stroke, both beyond the square's boundaries. Notice that where the paper is dry (outside the box), strokes have hard edges. Where wet (inside the box), strokes bleed, forming soft edges. Experiment with a second color to see how it flows into the first.

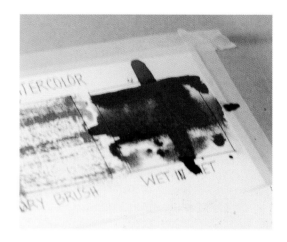

Combining Techniques

Try to use at least two different techniques in every painting. Whenever you combine techniques, you're on the road to an exciting image. For example, paint a landscape with a wet-in-wet sky, then use the drybrush technique for grasses in the foreground. In a still life, a graded wash will help define round objects like apples in a bowl. In the same painting, a tablecloth may have a flat wash for contrast.

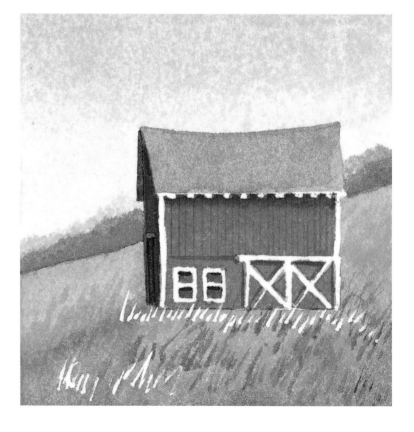

Elizabeth Horowitz
RED BARN
Watercolor on paper,
$4^{1}/_{2} \times 4^{1}/_{4}$" ($12 \times 11$ cm).

Values

The term *value,* as used in art, refers to the degree of lightness or darkness on a scale of grays, ranging from black to white. All other colors can be similarly scaled. The darker shades of a color are said to be lower in value; the lighter tones, higher. Numerous gradations exist between darkest and lightest. For watercolor, a five-point system is adequate to define form and assist in representing realism and texture. When light strikes an object, its value gets paler near the light source and darker near the shadow side.

Exercise Preparation

Use a No. 2B pencil on the five Pencil Value squares you prepared earlier. Sold at art-supply stores, No. 2B has the soft graphite that's best for sketching on

watercolor paper, as it erases easily (use a kneaded eraser). To fill in the squares:

- Make the first square as solidly dark as you can.
- On the next square, use less pressure to fill in a lighter value.
- On the next two squares, go lighter and lighter.
- Leave the last square white.

A pencil value scale is preparation for drawing a pencil value sketch of a subject before beginning a painting. Then, based on the value sketch, the goal is to mix paint that corresponds in value to the pencil sketch. In the following exercise, we use the "subtractive" method, creating values from dark to light. When the process is reversed, creating values from light to dark, it's known as the "additive" method.

Exercise: PAINT VALUES SCALE

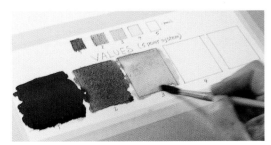

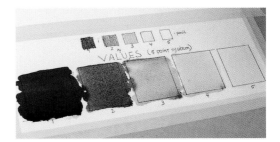

STEPS 1, 2, 3 Using the second pile of paint put on your palette earlier, load your No. 6 round brush with color and work in horizontal strokes from left to right, then right to left, in a flat-wash technique, covering the first square of your Paint Values scale with as dark and flat a color value as possible. Dip your brush once in clean water, wipe it on the jar's edge, and paint the second square. It should be lighter in value. Without going back to the palette for more color, dip your brush twice in water, wipe on the jar's edge, and paint the third square. It should be lighter still.

STEPS 4, 5 Dip your brush in water three times, wipe once, and paint the fourth square. It should be even paler. Give your brush a good swish in water. Be sure no paint is clinging up inside the ferrule (metal collar) of the brush, and paint the last square. Do your squares read from dark to light, as shown? If not, try again. If your fifth square is still too dark, blot with a paper towel until it's almost white, just barely tinted with color.

"Holding" the White of the Paper

When some parts of a watercolor painting are deliberately left unpainted, it's called "holding" the whites. The white of the paper actually becomes part of your palette, representing the whitest, brightest areas of your picture. Using the white of the paper is high up in the order of importance in planning a watercolor painting. There is no erasing in watercolor, and only some colors can be lifted or lightened by blotting. So planning ahead is essential when you want to keep color away from areas of your painting that are meant to be pure white. There are four ways to do it. I'll review the first three briefly, then show you my favorite and most effective method for holding all the white: liquid mask.

The first way is to paint around the areas to be kept white. This can be difficult and tedious when reserving white in small areas, as for tiny beams of light on an object or all the whites in a polka-dot pattern.

Some artists use masking tape to reserve white areas, often for straight edges, as in a striped pattern, horizon, or the edge of a roof. Paint won't flow under the tape if applied securely, but if the tape isn't pulled up carefully after the paint around it has dried, the watercolor paper will tear, ruining the painting.

Another method, and a last resort, is scraping away paint with a razor blade or matte knife to remove color and get back to the white of the paper. But once the paper has been scraped, its fibers are damaged, and that area takes on a different texture foreign to the rest of the paper.

Best Method: Liquid Mask

The fourth and easiest, most effective application is liquid mask, a rubbery latex product. Also known as friskit, it is usually white, but also comes in neon colors for greater visibility while painting on white paper. When it dries to a smooth, nonporous surface, it can be gathered into a ball that sticks to itself as it peels up.

Place liquid mask wherever you want to hold whites or highlights. The glint in an eye, the whites of nets or sails, floral details, blades of grass, wires and roof lines are just some subjects that may require liquid mask to hold the whites.

Applying Liquid Mask

Buy a small bottle, as liquid mask has a short shelf life and dries up quickly, especially when exposed to air. Shake the bottle vigorously. For one painting, put just the amount you expect to use in a small, sterile jar (baby-food jar is ideal). If thick globs fall into the jar, throw it out and refill.

For application of liquid mask to small details, use a round toothpick or a long wooden barbecue skewer, my favorite tool for the job. For tiny dots, as in the pistils of a flower, hold the stick at a 90-degree angle. Otherwise, dip and hold it like a pencil at a 45-degree angle. If blobs form at the tip, wipe them off and redip. For larger areas, the back end of a brush handle, Q-Tips, sponges, or a brush may be used, but the brush should be only a cheap craft brush, never a sable. Good brushes will be ruined by liquid mask. Also ask your art-supply retailer about other applicators recently introduced: a squeeze bottle with a needlelike nozzle, and a rubber, nonabsorbent brush for

large areas. Choose the tools that suit your needs, comfort, and budget.

If you make a mistake and liquid mask drops where you don't want it to be, let it dry completely and pick it up when removing all the other mask.

It must all dry thoroughly on your pencil sketch on dry (never wet) watercolor paper before painting. Before removal after painting, all paint and paper must be dry. Liquid mask dries from opaque white to a clear, milky white.

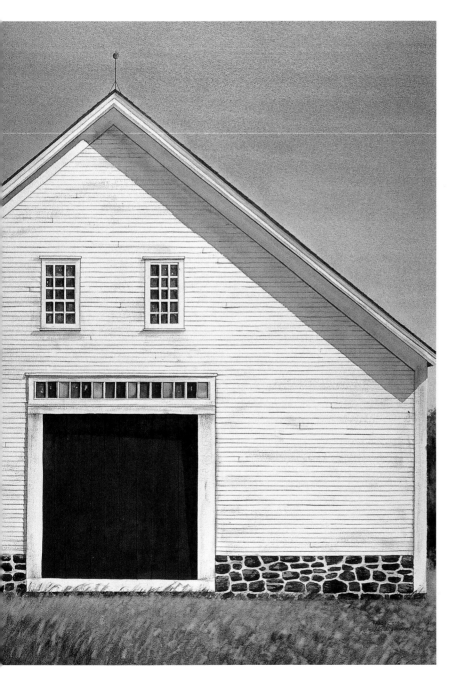

Elizabeth Horowitz
RED DOOR
Watercolor on paper,
40 × 30" (101 × 76 cm).

Planning and holding the whites is an important fundamental in watercolor art. Here, I reserved white on the front of the barn and on all the mortar around the stones in its foundation.

Removing Liquid Mask

After you've completed your painting, remove the mask. It's best not to leave mask on your paper for more than a week or so, as it may be harder to remove and discolor the paper.

The best way to remove liquid mask is with a rubber-cement pickup eraser made expressly for the purpose. Peeling or rubbing dry mask picks up some, but not all. To make a substitute pickup eraser, pour some liquid mask in a bowl, let it

A rubber-cement pickup eraser, made expressly for the job, is the best tool for removing liquid mask. Always work the eraser in one direction.

LIQUID MASK TIPS

■ Never stack or place anything on top of an unfinished painting with liquid mask on it (even if the mask is dry). The mask will be more difficult to remove.

■ Seal the liquid mask bottle with masking tape when not in use, and store it upside down in a sealed plastic bag. Protect from frost or high heat.

■ Dried liquid mask does not wash out of clothing.

■ John Singer Sargent and Winslow Homer were masters of planning and holding the white of the paper. Study Sargent's watercolors of Venice and Homer's views of Bermuda to see how the white of the paper makes their paintings glow with luminosity.

dry, then roll it into a ball. Like rubber cement, liquid mask sticks to itself.

Move the pickup eraser over masked areas in one direction at a time. Pick off pieces that cling to the eraser. The eraser can also be cut with a scissors to keep its edge flat. Be gentle so the eraser won't peel up the paper as well. (If it does, the liquid mask may be old, has been left on the paper too long, or the paper wasn't dry.) When you think all the mask has been removed, close your eyes and rub your palm over the dry artwork. If any mask remains, your fingers will feel what your eyes cannot see.

Creating Soft Edges

When liquid mask is removed, it leaves very hard edges, which are best removed in some areas to conceal the technique. To do so, use an old, flat, stiff brush: ideally, a 1/4" flat oil-painting brush. When you press its bristles into your palm, they remain rigid and won't bend. Dip the brush in clear water, then rub the hard painted edges until they soften. Blot any excess water and let dry.

Another way to soften edges is by adding color. Use a No. 2 brush with a fine point. Leave some of the white paper showing as you add color to soften an edge.

Sponge Texture

Here's one more useful softness technique, particularly helpful when depicting foliage. Practice with a natural "sea silk" sponge (not a synthetic kitchen sponge). Take a small, dry piece of the sponge, dip it in paint, and dab it on paper to simulate foliage. Turn the sponge as you work to alter the impressions. You'll build on this technique further with later exercises that involve trees.

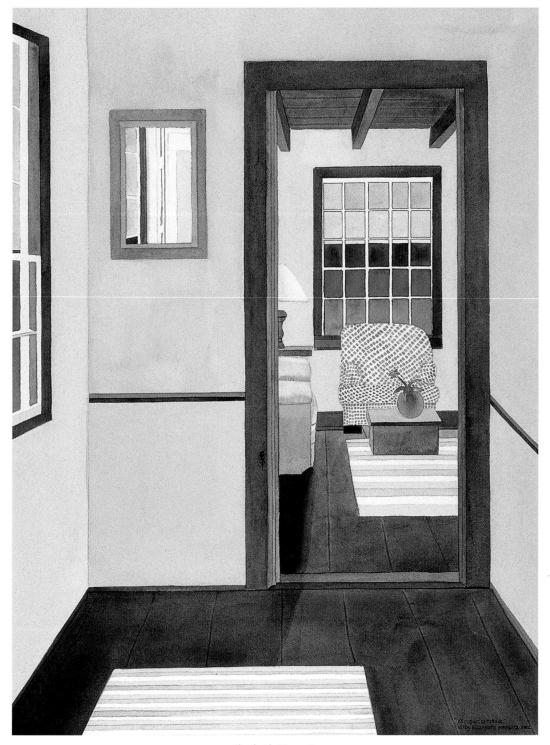

Elizabeth Horowitz
YELLOW INTERIOR
Watercolor on paper, 24 × 18" (61 × 46 cm).

Multipaned windows, with many white sash bars, are much easier to paint when liquid mask is used to hold the white of the paper, as I did here.

"TIE-DYE SKY"
©by ELIZABETH HOROWITZ·2002

Color

Color is light. The absence of light is black. In the mid 1600s, Sir Isaac Newton shined a beam of white light through a glass prism and demonstrated that it decomposed into a spectrum. The resulting rainbow of red, orange, yellow, green, blue, indigo, and violet comprises our fundamental colors. All colors combined create black. Since Newton, much has been learned by science about color chemistry, how the eye perceives color, and how the mind interprets it. But for artists, what's most important is deciding which colors to use where, and how to harmonize and mix them to enhance our visual vocabulary.

Colors have three aspects to their identity: hue, chroma, and value.

- **HUE** describes the actual color or direction toward which it leans: red, reddish purple, yellow, bluish, and so on.
- **CHROMA** and intensity are synonymous. A high chroma color is the hue at its most intense, pure, or brilliant state. In watercolor, a color straight from the tube, undiluted, is full saturation, or high chroma. When diluted with water, red turns toward pink, a lower chroma.
- **VALUE** is the color's position in relation to black and white or light and dark. For example, yellow has a high value (close to white), whereas purple has a low value (close to black). All colors have their own inherent value. Obviously, yellows are the lightest, and blues, browns, and blacks are darkest. On a color wheel, intense colors opposite each other are of equal value.

Elizabeth Horowitz
TIE-DYE SKY
Watercolor on paper,
12 × 9" (31 × 23 cm).

Color Wheel

The color wheel is another way to classify colors, showing them in the order of the rainbow's spectrum. On the color wheel there are three each primary colors, secondary colors, and tertiary colors.

PRIMARY COLORS—red, yellow, and blue—cannot be obtained by mixing any other colors together. But from them, theoretically, all other colors can be created. Some artists limit their palette to primary colors for simplicity and/or economy, and never buy other tube paints. But watercolor paints come in a variety of reds, blues, and yellows, so it's important to know which are considered the primaries: cadmium red, cadmium yellow, and ultramarine blue.

SECONDARY COLORS—orange, green, and purple—are produced by blending two primaries. Red plus yellow makes orange; yellow plus blue makes green; red plus blue makes violet. However, I often use violet from the tube, as it can look more vivid than a blended violet. But the two different violets—one mixed from primaries, one from a tube—are nice used together for a subtle variation.

TERTIARY COLORS are intermediates produced by mixing a primary with a secondary, such as blue with green or red with violet. Tertiaries rarely produce a fresh hue and are always duller than primaries or secondaries.

COMPLEMENTARY COLORS are directly opposite each other on the color wheel. When mixed together, such as yellow and purple, they produce a neutral. Neutrals enhance all other colors.

EARTH PIGMENTS were originally made from minerals, semi-precious stones, and plant roots. On the watercolor palette, earth tones take in ochres, umbers, siennas, and madders. Burnt sienna, a warmed orange, is also known as the "Magic Mixer." It has the ability to transform other colors into earth-toned neutrals without destroying their identity.

ANALOGOUS COLORS are those that fall next to each other on the color wheel. Think of them as good neighbors that relate well to one another and become harmonious friends (or even more; purple and green love each other!).

Elizabeth Horowitz
FLYING COLORS
Watercolor on paper, 15 × 41″ (38 × 104 cm).

This painting has many different color groupings. How many can you identify? Try to locate the colors that are primary, complementary, analogous, warms and cools, and full-spectrum rainbow hues.

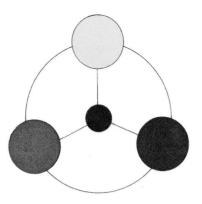

Primaries on the watercolor wheel are these three specific tube colors: cadmium yellow (not lemon yellow or gamboge), cadmium red (not crimson or rose), and ultramarine blue (not cobalt or cerulean).

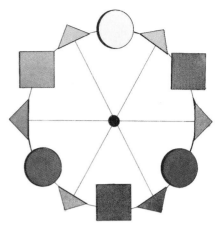

In this completed color wheel, the circles identify the primary colors; the squares are the secondaries, produced by combining two primaries; and the triangles are the tertiaries, produced by combining a primary with a secondary.

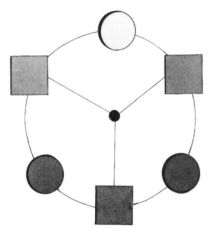

Secondary colors, orange, green, and purple, form an interesting color scheme.

The transparent property of watercolor demonstrates the production of secondary colors, as shown in the overlapping areas.

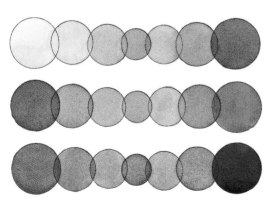

Complementary colors produce powerful neutrals when combined.

These gradations of earth colors, from top, clockwise, are yellow ochre, raw umber, burnt umber, sepia, burnt sienna, and Venetian red. Center, from left: brown madder (alizarin), raw sienna, and raw umber.

Color Temperature

Red, orange, and yellow (half of the color wheel) are known as warm colors. Purple, blue, and green (the other half of the wheel) are known as cool colors. An easy way to remember color temperature is to think "south of the border" for warm, sunny colors, often seen in Mexican crafts with their hot reds, orange, and yellows. For cool colors, think of Alaska and its snowy landscape, bluish glaziers, distant purple mountains, and green forests. When painting a still life or landscape with a single light source, use contrasting warm and cool colors. Think of the light source as the warm sun, its golden-yellow light contrasting with cool purple and blue shadows. A mixture of warm and cool colors is especially effective on a white subject, such as the sun-drenched buildings of Greece or a snow scene. A sunny light source will make white buildings glow with warm yellows, oranges, or pinks, and the cast shadows become cool purples and blues. Thus, light has the ability to alter the temperature of a color and create drama and atmosphere in a painting, especially when the sun casts its longest shadows at dawn or dusk.

Creating Grays

Grays result from mixing all three primary colors or two complementaries. They can be dull, lifeless, or luminous, depending on how they are mixed, and which color temperature (warm or cool) they favor.

Grays that have a blue or purple cast are cool. Grays with an obvious red or yellow cast are warm. Either or both can enhance an ordinarily gray subject, such as a cityscape, by playing appealing warm and cool colors against each other.

Color Harmony

Try to establish a balanced relationship among colors. For example, if your painting is predominately red and green (complementaries), and you want to introduce another color, reach for a neighbor of red or green, and harmony will reign.

If your painting is predominately cool blues and greens, reach across the color wheel for a complementary color to add impact. For instance, an orange-red barn will add punch to a blue-green landscape.

COLOR TIPS

- Prussian blue, sepia, and violet mixed together produce a richer black than black from a tube.
- Paint light watercolors first, then darks. Begin with yellow, as it can sully or get muddy easily.
- Don't overmix colors on your palette. Let them blend subtly on your paper.

- Watercolor dries one value lighter. Test colors on scrap paper first, let them dry, then check for value and intensity.
- Don't combine more than two colors; mixing three makes mud.
- Primary colors are the most brilliant; secondaries, less brilliant; tertiaries, least brilliant.

"Dynamic Duo" is the nickname I gave my favorite color mixture—a blend of burnt sienna and ultramarine blue, which produces exquisite warm or cool grays, depending on the proportions used. These grays are richer and more exciting than tube colors such as Davy's gray (dull) and Payne's gray (very blue).

From left, warm colors and cool colors are on opposite sides of the color wheel; analogous colors fall next to one another on the wheel.

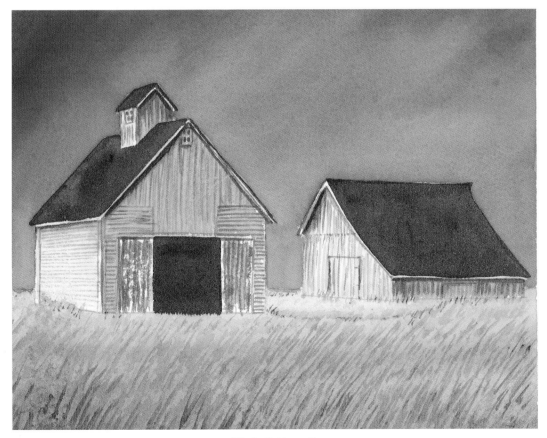

Elizabeth Horowitz
HOT SKY, COOL BARNS
Watercolor on paper, 7^1/$_2$ × 9^1/$_2$" (19 × 24 cm).

The secondary colors (orange, green, purple) wrap this simple subject in a powerful color scheme.

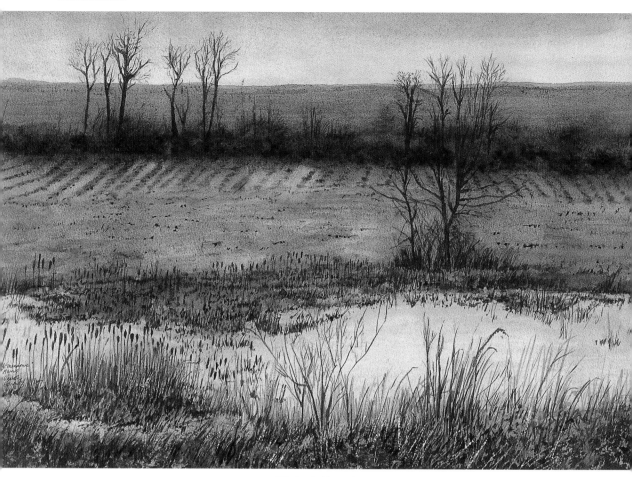

Elizabeth Horowitz
MARSH AND MEADOWS IN MORRIS
Watercolor on paper, 15 × 21" (38 × 55 cm).

By dominating my palette with a range of earth colors, this painting takes on a warmth that reflects and reinforces the serenity of the natural setting.

OPPOSITE: Elizabeth Horowitz
BLUE SHUTTERS
Watercolor on paper, 30 × 22" (76 × 56 cm).

The cool colors on shutters and foliage play against the warm tones of the stucco wall in this exterior scene.

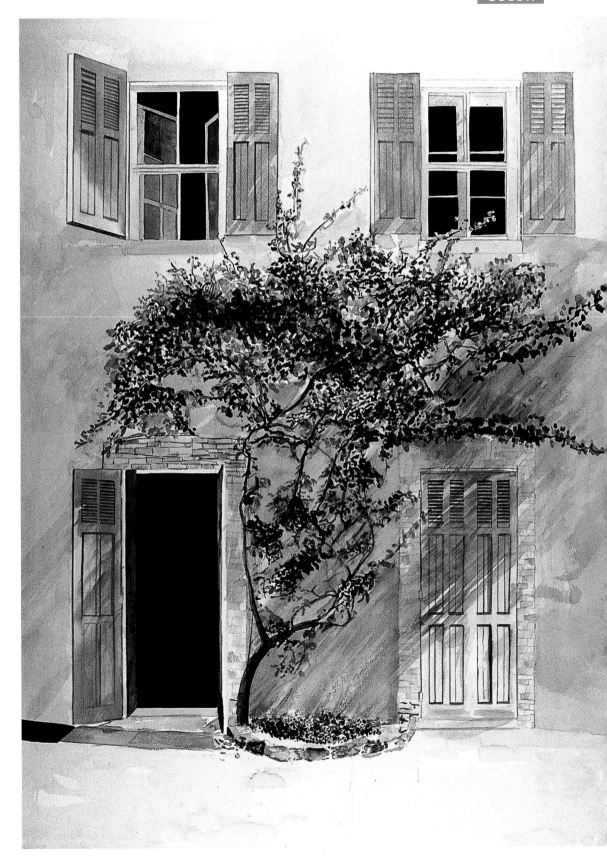

Transparency & Glazing

Transparency is the most unique quality of watercolor, as it allows the white of the paper to shine through, which cannot be said of acrylics, oils, or any other paint. To make a watercolor paint that is opaque by nature transparent, or to lighten a color, just add water. Because watercolors are pure pigment with no white or chalk added to them, they can achieve luminosity like no other art medium.

Think of stained glass to fully appreciate the concept of transparency. Think of pouring milk into a clear cup of tea to appreciate how a transparent mixture becomes opaque. In the same way, white paint added to watercolor will cancel out the transparent effect and produce a tint. However, the instruction in this book and the paintings shown as examples are all based only on transparent watercolor. So no white paint is ever used in the exercises ahead—only the white of the paper.

In addition to transparency, we focus on glazing in this chapter. Glazing is painting a wet wash over a previously dried wash of watercolor. Glazing is also a way to mix colors on the surface of the paper, rather than on the palette. It produces exquisite color. Before glazing, always test to see that your first layer of paint is dry by pressing the back of your hand lightly over it. If it feels cool and damp, it's still wet, and shouldn't be glazed yet. Be patient—or use a hair dryer to hasten drying. But be careful not to push a puddle of paint. Hold your hair dryer at least a foot above your flat paper, and move it in a slow, side-to-side motion.

Elizabeth Horowiz
**NEW HAVEN, WARM
AND COOL (DETAIL)**
Watercolor on paper,
11 × 10″ (28 × 26 cm).

Shapes

In this chapter, we'll also focus on shapes. The choice and arrangement of shapes in a painting is often more important than the subject itself. It has been said that a good painting can be composed with just a dozen shapes. Modern artists, particularly, have used shape in revolutionary ways to make their artistic statements. Study the work of Piet Mondrian, whose grids interspersed with bold primary colors are based entirely on geometric shapes. When Henri Matisse was afflicted with arthritis and failing eyesight during his last years, and could no longer paint, he created exciting large works made of shapes cut out of colored paper. Joan Miró designed his own calligraphic style using amorphous shapes. Joseph Albers paid homage to the square in his works. Mark Rothko pursued the rectangle. Many Ellsworth Kelly and Frank Stella works are not only based on shapes, but are painted on shaped canvases.

Glazing is the technique of painting a wet wash (or layer) of color over a previously dried wash (or layer) of color, to give the optical illusion of a third color. It's essential that the bottom layer be absolutely dry, or the result will be opaque, not transparent, when you apply the second color. For maximum transparency, use transparent colors. These are magenta and turquoise-blue. (For other transparent tube watercolors, review the list in Chapter 1.)

Here are some of the shapes to consider in selecting a few for the next exercise. Even when such simple shapes as circles and squares are used, by varying their sizes, you can build an animated and colorful painting. When areas are overlapped with glazing, additional colors come into the picture.

Elizabeth Horowitz
POP
Watercolor on paper,
9 × 12" (23 × 31 cm).

This painting of shapes demonstrates the beautiful transparent quality of watercolor. Also note how glazing expands the palette: purple results from blue over red; orange from rose over yellow.

Elizabeth Horowitz
KALEIDOSCOPE
Watercolor on paper, 9 × 12" (23 × 31 cm).

This was painted with transparent granular watercolors on rough paper to enhance visual interest and texture.

Exercise Preparation

The goal of the next exercise is to paint shapes with overlapping areas that display watercolor's transparent quality. First, to prepare the shapes:

- Select one, two, or three shapes of different sizes. They can be geometric, abstract, representational, or amorphous.
- Sketch the shapes on thin cardboard (cereal box or similar).
- With scissors, cut out the shapes, making templates of them.
- On the remaining cardboard, trace your templates to make a few more—the same shapes, but in larger and/or smaller sizes. Cut them out. Now you have your two or three shapes in six or eight templates of different sizes.
- Arrange your templates on watercolor paper and trace them with pencil. Move the templates around until you've composed a complete picture.
- If your shapes are geometrics, create an abstract design. Or form them into a seascape made of crescents for boats and triangles for sails. Overlap the shapes of the sails. Draw a horizon line. Add a sun or clouds.
- Rectangles and squares can be used to build a cityscape.
- If your shapes represent objects—silhouettes of flowers, houses, cars—use many of each; scatter them, overlap some, create a garden, a street scene, or just an interesting repeat pattern of their silhouettes.
- Use your imagination!

- Finally, use all of your paper. Go to the edges and perhaps have some shapes poking in at the edges.
- When you're satisfied with your composition, you're ready to paint!
- If you've drawn a scene, not an abstract composition, paint the shapes first, the sky or background later.

Adding an Ink Outline

When all the paint is dry on the exercise on the opposite page, as an optional addition, you may make a stronger graphic statement by outlining some or all of the shapes, using a waterproof black pen. Black line enhances contrasts among the various colors and glazes, making the painting look like stained glass. Then sign and date your art with ink in the lower-right corner, about a quarter-inch up from the edge to allow for a mat and frame.

If you enjoy the following exercise, try it again using a different color scheme—perhaps a full palette, analogous colors, or a group of your favorites. If you created an abstract design, try to construct a scene composed of shapes. Be daring! The possibilities are infinite. Wet a shape with clear water and try to bleed or drop in two colors and watch them flow together. Have fun with color and glazing. Make notes about the colors you liked best in the overlapped areas for reference in future paintings. The colors produced from glazing are richer than the same colors mixed together on the palette. Glazing can unite the elements in a painting. Transparency and glazing are powerful tools in building a strong visual vocabulary.

Exercise: GLAZING SHAPE OVER SHAPE

STEP 1 Starting with one pair of overlapping shapes, with a No. 2 round brush, paint the palest color first. Allow drying time before glazing the shape that overlaps. Are you working at a 30-degree angle?

STEP 2 To paint a shape that overlaps another shape, first paint the outside of the shape—here, the part of the blue square that doesn't overlap the yellow circle.

STEP 3 Paint the overlap part last, using as *few strokes* as possible to glaze. Start with one stroke only, going in one direction.

STEPS 4, 5 On this size overlap, just another stroke or two should complete the glaze. Don't "windshield wiper" with your brush! If the first shape was yellow and the next shape touching it was blue, the overlapping area should be green. Complete your painting by following the same glazing procedure with all other over-lapped areas in your picture.

Elizabeth Horowitz
NEW HAVEN, FULL CHROMA
Watercolor on paper, 11 × 10" (28 × 26 cm).

Based on simple geometric shapes, glazing and warm colors used at full chroma give this painting its intensity.

Elizabeth Horowitz
PARIS, LA SEINE
Watercolor on paper, 22 × 30" (56 × 76 cm).

The transparent glaze technique helps cast a misty atmosphere over this monochromatic scene.

Student Gallery: GLAZING AND SHAPES

Carolyn Nelson
ECLIPSE
Watercolor on paper, 12 × 16″ (31 × 41 cm).

Audrey Bartner
HAPPY BIRTHDAY
Watercolor on paper, 12 × 18″ (31 × 46 cm).

Tish Bialecki
RAINBOW DREAMS
Watercolor on paper, 12 × 16″ (23 × 41 cm).

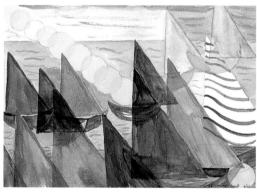

Lyle Brehm
SAILING
Watercolor on paper, 12 × 16″ (31 × 41 cm).

Carola McAndrew
TRANSPARENT SHAPES
Watercolor on paper, 11 × 15″ (28 × 38 cm).

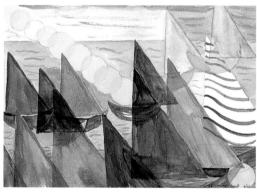

Jill Vondervor Frank
SUN AND SAIL
Watercolor on paper, 10 × 14″ (26 × 36 cm).

Deborah Herbert
RACING SAILBOATS
Watercolor on paper, 12 × 16" (31 × 41 cm).

Sallie Smith
THE GARDEN
Watercolor on paper, 12 × 15" (31 × 38 cm).

Allison Aniskina
SHAPES
Watercolor on paper, 9 × 12" (23 × 31 cm).

Rosemary Boehm
COLORS DIVERGE
Watercolor on paper, 18 × 12" (46 × 31 cm).

Kathleen Fitzgerald
ON THE WAVES
Watercolor on paper, 12 × 16" (23 × 41 cm).

Patterns

To add interest to a painting, especially a still life or interior scene, think *pattern*. In bringing patterns to your work, try to go beyond basic polka dots, stripes, and checkerboards. But even with those common geometrics, using one shape over and over or interlocking it with another may produce a fresh look. Razzle dazzle viewers with clever patterns. It's a surefire way to grab their attention.

Patterns are everywhere in the world around us. Throughout the ages, architects and designers all over the globe have used the power of patterns to build up facades and create eye-catching surfaces. In the natural world, as well, patterns are ubiquitous. Look at the camouflage of butterflies, ladybugs, zebras, leopards, tree frogs, and pinto ponies. The fronds of a fern form a pattern that repeats in different sizes. Petals of pansies, orchids, and numerous other flowers have fascinating patterns. The massing of blossoms in a bouquet or garden create patterns. Clouds form patterns. The home is an abundant source of patterns. Look at carpets, wallpaper, upholstery fabrics, tableware, and parquet floors to discover how varied and imaginative patterns can be.

Among painters, study the work of Henri Matisse, a master of motifs, and Gustav Klimt, to see how they enriched interior settings and models' clothing with colorful, intricate patterns. See how Vincent Van Gogh turned quiet farm fields into explosive patterns of dots and dashes.

In watercolor, patterns can be created in a calligraphic way with brush-strokes. Once you become aware of patterns, you will see them everywhere, providing you with an ongoing source of inspiring reference material to enliven your watercolor art. Complementary colors combined with pattern can create visual vibrations.

Most of all, your goal is to have fun inventing patterns!

Elizabeth Horowitz
RUSSIAN SPIRES
(DETAIL)
Watercolor on paper,
13 × 7" (33 × 17 cm).

Exercise Preparation

The next exercise is painting umbrellas with varied patterns. In preparation, keep these points in mind:

- Umbrellas are three-dimensional, so make their lines curve to suggest contours. If the umbrella ribs are drawn as straight lines, they will look like flat pinwheels, not umbrellas.

- Be sure the paint is dry before working an area next to it. Otherwise, colors will bleed together. Skip around your paper as you work. Let one part dry while painting in another area.

- Rinse your brush thoroughly between colors to maintain color purity.

- Use two containers of water: one for rinsing the brush; the other to clean it before dipping into the next color.

- Again, always keep your paper propped up at a 30-degree angle to let your paint flow gently downward.

When put into repeat patterns, even simple geometric forms such as these can enhance watercolor paintings, particularly still lifes and interior scenes.

Exercise: PATTERNED PARASOLS

STEP 1 With a No. 2B pencil on 9-x-12" water-color paper, lightly sketch a series of partial circles to suggest overlapping umbrellas. Draw the circles freehand or trace them, using a small plate as your template. Make the curves a bit smaller toward the top of your drawing to give the illusion of depth so the umbrellas recede into the background.

STEP 2 Draw the center cap that holds the umbrella's ribs, then draw the ribs as they curve over each of the umbrellas. The curved lines will make the shapes look three-dimensional, instead of like flat discs. Begin adding simple patterns and try to vary then, giving each umbrella a different look. Keep your pencil light so it won't show through your finished painting, but dark enough to follow.

STEP 3 Decide on a color scheme. Whatever you choose, plan some areas to be paper white. Apply liquid mask to "hold" those whites. Although white liquid mask is used most often, since it won't show up here, I've colored those areas orange where mask is applied. Put liquid mask wherever your design may be tedious to paint. In this example, it's the dots and skinny stripes that are to remain paper white, as they would be difficult to paint around if not protected with liquid mask.

TIPS FOR COMPLETING YOUR PAINTING

- Start painting the patterns on your umbrellas with light colors first.
- Skip around your paper to let paint dry and create hard edges for the patterns.
- Use the point of your No. 6 round brush for smallest details.

- When your painting is dry, remove the mask with a rubber-cement pickup eraser.
- Sign and date your masterpiece in the lower right corner, a quarter-inch up from the bottom so a little margin is left for a mat and frame.

Elizabeth Horowitz
PATTERNED PARASOLS
Watercolor on paper, 10 × 14" (25 × 36 cm).

Student Gallery: PATTERNED PARASOLS

Janet Slivorsky
CROWDED BEACH
Watercolor on paper, 10 × 14″ (25 × 36 cm).

Ilene Oppenheimer
UMBRELLAS
Watercolor on paper, 16 × 20″ (41 × 51 cm).

Allison Aniskina
A DAY AT THE BEACH
Watercolor on paper, 9 × 12″ (23 × 31 cm).

Vinnie Dachowski
FANCY UMBRELLAS
Watercolor on paper, 12 × 16″ (31 × 41 cm).

Lora Cooper
TOASTY TOES
Watercolor on paper, 11 × 15″ (28 × 38 cm).

Carola McAndrew
CHINESE UMBRELLAS
Watercolor on paper, 8 1/2 × 8 1/2″ (21 × 21 cm).

Lyle Brehm
MARKET PLACE
Watercolor on paper, 12 × 16″ (31 × 41 cm).

Louis Giacona
NO RAIN
Watercolor on paper, 12 × 16″ (31 × 41 cm).

Kathleen Fitzgerald
CAN YOU HEAR ME NOW?
Watercolor on paper, 12 × 16″ (31 × 41 cm).

Carolyn Nelson
UMBRELLA TREASURES
Watercolor on paper, 12 × 16″ (31 × 41 cm).

Sallie Smith
UMBRELLAS IN PARADE
Watercolor on paper, 12 × 16″ (31 × 41 cm).

Svetlana Aniskina
ELEVEN UMBRELLAS
Watercolor on paper, 12 × 16″ (31 × 41 cm).

Additional Subjects for Patterns

Hot-air balloons, a boat's sails, piles of children's pinwheels, balls, blocks, and other toys are all potential subject matter that have patterns or can be adorned with colorful patterns in your artwork. Bicycle spokes and the interesting shadows they cast on a paved road or sidewalk form patterns. Buildings are composed of varying shapes for windows, doors, towers, and all sorts of architectural embellishments that can inspire numerous watercolor paintings that make patterns out of arrangements of shapes.

Elizabeth Horowitz
MARKET
Watercolor on paper, 15 × 22" (38 × 51 cm).

The arrangement of strong patterns and vivid color in this wonderful outdoor market, viewed from a second-story window, turned me on and whispered, Paint me! My palette features sprinkles of gray-toned neutrals in the shadows to enhance and accentuate the dominating primary colors, cadmium red, ultramarine blue, and aureolin yellow. Notice that primary colors are adjacent to secondary colors, such as lemons next to purple plums, for harmony and unity. The awning patterns of simple stripes sandwich in a tightly cropped, framed view of the produce.

Elizabeth Horowitz
**BATTERY PARK
LOOKING NORTH,
NYC**
Watercolor on paper,
40 × 30" (101 × 76 cm).

*Skyscrapers offer a
riot of shapes in their
combination of varied
roofs and repeat
patterns of windows.*

PATTERN TIPS

- Note the many pattern variations in the "Student Gallery" umbrellas (pages 54–55), including the one with feet poking out on the sand, adding a whimsical touch.
- To preserve your light pencil sketch before you start painting your pattern, you might apply a little clear water over it, and the graphite will never erase completely, but will remain visible to guide your application of paint.
- By using liquid mask on areas of a pattern, the white of the paper becomes part of the palette, and often just the accent needed to make the painting sing.
- Always try to keep the mixing area of your palette clean to impart true colors to your patterns.

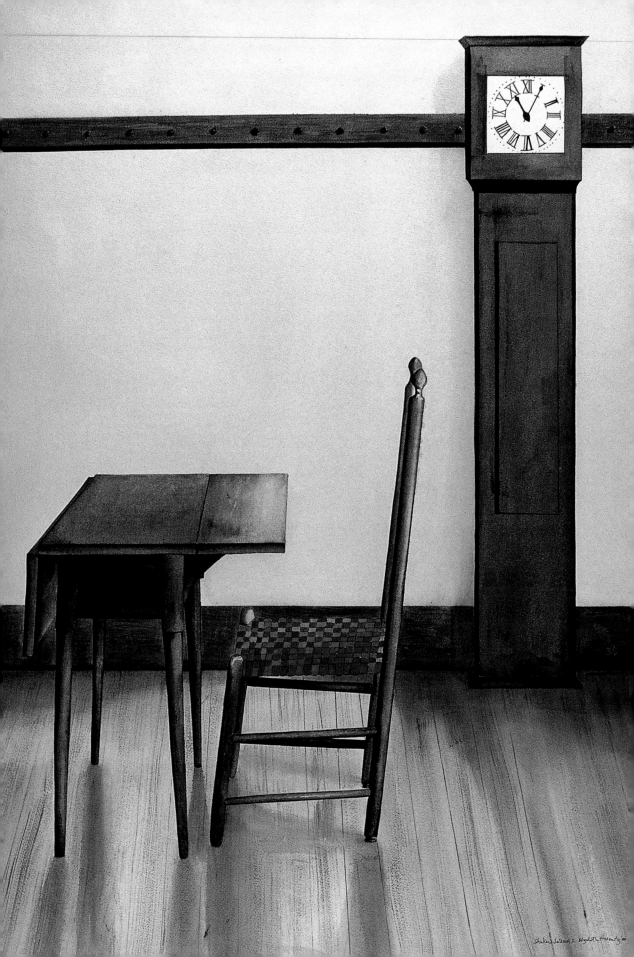

Shaker Interior I, Elizabeth Horowitz

Light & Shadow

Light defines form, articulates texture, creates dimension, and adds interest and substance to a painting. How light falls on objects also affects their colors and values.

There are four types of lighting to consider in planning a painting: side lighting, back lighting, overhead lighting, and diffused lighting. Try to notice these different types, both artificial and natural light, as they fall on objects. Observe how natural light affects objects at different times of day, in different weather and seasons. Which types of lighting do you prefer? Study the paintings of Georges de la Tour, who used a single candle as a light source to make his subjects glow. Jan Vermeer often illuminated his center of interest with light streaming through a window.

When artists discuss the anatomy of light, two other terms are used: highlights and reflected lights. Highlights are the brightest spots in a painting—the white areas or those with the highest value. Think of the shine on an apple, the twinkle in an eye, the sun glint on water, or raindrops on a leaf. Reflected light is light that reaches an object after bouncing off a nearby object. It's never as light as a highlight.

In terms of the best times of day to find the best light source, many artists love working during the "golden hour." Whether painting outdoors or working indoors with natural light coming through a window, artists know that daylight is most dramatic in early morning or late afternoon, when the sun casts its longest shadows at dawn and dusk, imparting a pink, orange, or golden glow.

Elizabeth Horowitz
SHAKER INTERIOR I
Watercolor on paper,
40 × 30" (101 × 76 cm).

Chiaroscuro

No discussion of light can be complete without talking about its partner, shadow. Together, the two determine the *chiaroscuro* of a painting—the technique of modeling form with the use of light and shade. From the Italian words for light and dark, chiaroscuro was developed by Renaissance artists who drew studies in graphite, sepia, or black ink, then added the lights with white chalk. They modeled form to an awesome level of anatomical precision, perfect proportion, and perspective. An allied term, *sfumato,* meaning "up in smoke," refers to the very delicate gradations of light and shade that make modeling so subtle that it has a hazy or smoky look.

The part that shadow plays in chiaroscuro is critical. Shadow is shade within defined limits. Shadows, like light, define form and articulate texture, but they also add drama to paintings. Shadows can even be the motivation and subject of a painting. Shadows may reflect the exact shapes of objects or be distorted or elongated. Shadows can form interesting patterns and abstract shapes. They may reflect the color of the object that is casting a shadow, or a shadow may show touches of the object's complementary color; a red apple may have green in its shadow. Shadows generally have soft edges, compared with the hard edges of the object casting the shadow.

Side lighting creates this strong cast shadow—the shadow of an object as it falls on another surface. Cast shadows may be abstractly exciting and become the motivation for a painting.

Back lighting throws shadows forward. Note that a cast shadow is darkest where the object meets the surface on which the shadow is cast.

Overhead lighting is the kind to use when you want the absence of cast shadows, as demonstrated here.

How light hits an object is analyzed in this "anatomy of a shadow."

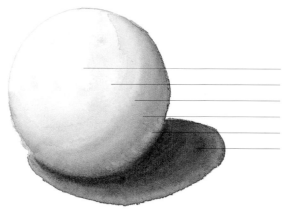

HIGHLIGHT

LIGHT

SHADOW

CORE OF SHADOW

REFLECTED LIGHT

CAST SHADOW

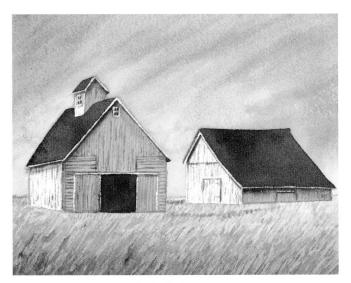

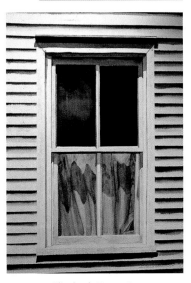

Elizabeth Horowitz
TWO BARNS ON THE PRAIRIE I
Watercolor on paper,
7$\frac{1}{2}$ × 9$\frac{1}{2}$" (19 × 24 cm).

Elizabeth Horowitz
SHAKER WINDOW I
Watercolor on paper,
40 × 30" (101 × 76 cm).

A monochromatic painting emphasizes light, shadow, form, and texture (left). Monochromatic harmony is established with a variety of subtle values (right).

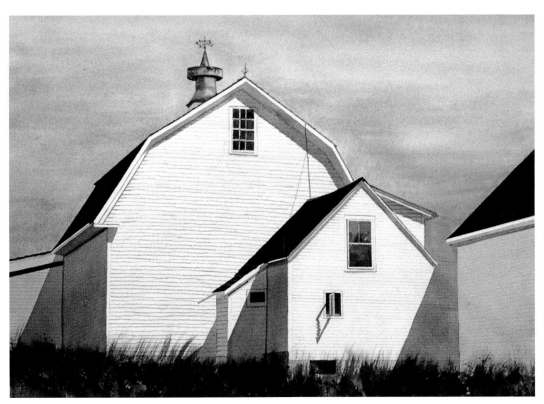

Elizabeth Horowitz
BARN, LINCOLNVILLE, MAINE
Watercolor on paper, 30 × 40" (76 × 101 cm).

In this rural scene, light and shadow combine to create an illusion of three dimensions.

Monochromatic Harmonies

Working with a monochromatic palette can help you to study light and shadow. Monochromatic means one color, and often, less is best. There can be great power in using a single color. It emphasizes light, shadow, form, and texture. It's also simpler and less expensive in terms of the amount of paint you use and tote if you're working away from home. I also find monochromatic paintings are best when the subject matter is kept simple.

Exercise Preparation

This will take only four minutes! In preparing you for the next exercise, it serves a basic purpose of this book: to sharpen your observation skills by having you practice drawing what you *see*, not what you *think* you see. This exercise preparation will also help you build your visual memory.

■ Gather sketch paper, a kitchen timer, a pencil, and a penny. If it's hard for you to see detail on a penny, use a nickle or a quarter.

■ Set the timer for three minutes. Sketch the front of the penny while looking at it. Make your drawing any size you wish, and record as much detail as you can in three minutes: Lincoln's profile, the date, the motto, and whatever else you see. Stop drawing when the timer goes off.

■ Turn your sketch over. Also put the penny away, out of sight.

■ Reset your timer for one minute.

■ Resketch the coin from memory. Try to draw as much detail as you can recall in one minute.

■ When the timer goes off, compare your two sketches. How much did you record from memory?

The goal of the next exercise, using one color only, is to create a range of values that capture the varied lights, shadows, and textures of the subject.

Exercise: MONOCHROMATIC PEPPERS

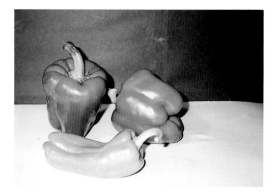

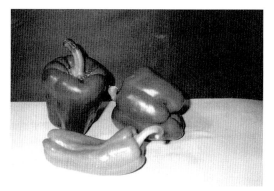

STEP 1 Study the color photo of green peppers. Note that *odds are better than evens* for a still life; somehow, an uneven number of items always makes for a more interesting picture. Here, a single light source, a lamp, was set up to shine on the veggies from upper left.

STEP 2 Study the black-and-white photo. When lighting a still life, don't rely on daylight from a window. The sun will change light and shadows in minutes, well before your painting is complete. Also be sure that your work table is lit in a way that won't put your hand in shadow as you work.

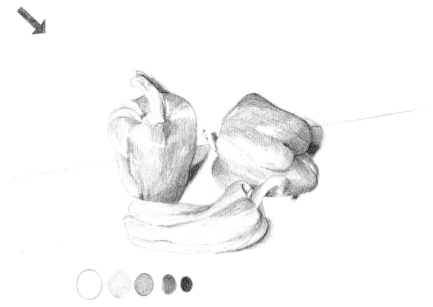

STEP 3 On drawing paper, make a five-point value scale with a No. 2 pencil. Then draw a tonal (value) sketch of the peppers. Note the light source with an arrow at upper left. Refer to the values in the black-and-white photo while sketching. Where are the darkest darks, the lightest values, the highlights? Also study my pencil sketch. Key and number where the five values fall: 1 is lightest, the white highlights; 2 is next lightest; 3, getting darker; 4, darker still; 5, darkest.

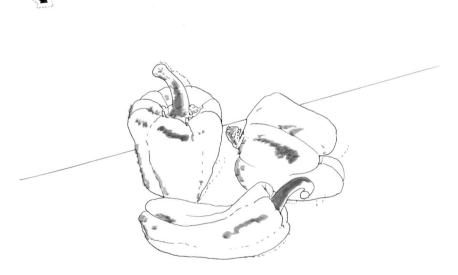

STEPS 4, 5, 6 On 9-x-12" watercolor paper, make a light line drawing of the peppers with your No. 2 pencil. (If not working on a watercolor block, tape all edges of your sheet to a board.) Your pencil sketch is your road map. Consider the light source from upper left as you apply liquid mask for whitest highlight areas. (I've used orange to show where the mask goes.) While the mask dries, prepare four values of a dark-value color on your palette, adding water as needed. The white of your paper will be the fifth value. Test each batch on scrap paper before using. Always work from background to foreground. When you paint the peppers, go from lightest to darkest values. Shadows should be painted last. Remove the liquid mask with a rubber cement pick-up eraser.

TIPS FOR COMPLETING YOUR PAINTING

- Select one dark-value color.. It's harder to get a five-value scale from a light color, so use a dark color only. In my example, it's Hooker's green.

- Squeeze four piles of paint on separate areas of your palette, where they won't run together when diluted. Be *generous* with your paint, as though it's a gift. Beginners often skimp on paint, then ask why their watercolors look pale!

- To prepare a gradation of values, spray two squirts of water on the first paint pile; four squirts on the second; six squirts on the third; eight squirts on the last.

- Mix and test each value on scrap paper for proper gradation before painting.

- Rinse your brush between mixings. Let the paint tests dry, because watercolor dries one value lighter.

- The white of the paper will serve as the fifth value.

- Liquid mask will simplify holding the highlights, or whites.

- Paint the background first (the usual procedure for still life or landscape). The background value should contrast with items in the foreground. In my pepper painting on the opposite page, I used a flat wash for the background at the top.

- I created the textured ground for my tabletop using a mesh bag (that onions came in) as a stencil stretched over my paper. That method is somewhat advanced, so experiment with it first before applying to your painting. Other options for your tabletop: Create another pattern or choose a wash technique (drybrush or graded wash) that contrasts with the flat wash of the background.

- Slowly paint the peppers, using your four values of mixed paint. Work from light to dark.

- For variety, combine techniques: drybrush here, graded wash there, and so on. The shadows should be painted last, and generally, with soft edges. Less water equals more control.

- To soften an edge, take a clean brush and make a stroke along the outer edge of the shadow while the paint is still wet. If it's not soft enough or a droplet forms, blot with a paper towel.

- Let your painting dry thoroughly before removing the liquid mask. Test with the back of your hand. If the surface feels cool, it's still wet. Wait longer.

- Remove the liquid mask with a rubber-cement pick-up eraser. Close your eyes and rub your hand over the painting. If you feel remaining mask, remove it.

- Soften the edges of highlights (where liquid mask was removed) with a stiff, synthetic brush dipped in clear water.

- Evaluate your work. Are shadows consistent with the light source throughout the painting? Do the painted values match your pencil value sketch?

- To lighten a value that was painted too dark, brush clear water over it and blot (don't rub) with a paper towel. This process is known as *lifting*.

- Finally, does your painting look too pale? The most common mistake made by new watercolorists is using too little pigment. A monochromatic study will zero right in on that problem. The darkest areas of your painting should be a full chroma of color (as dark as straight from the tube). If not, add more color to darken values where appropriate. The last touch: Proudly sign your work!

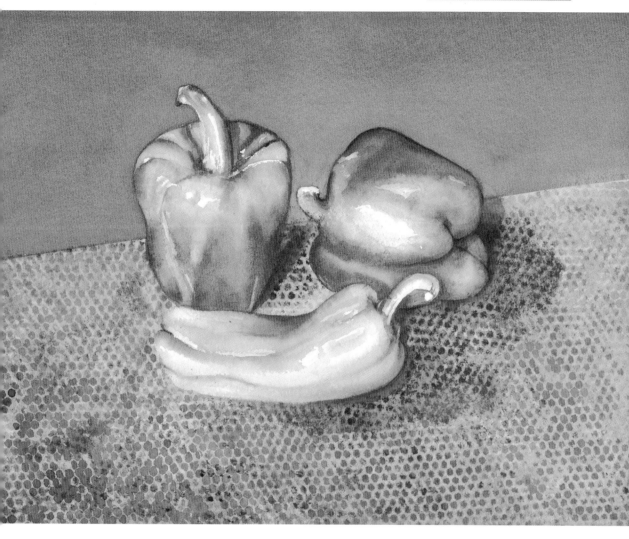

Elizabeth Horowitz
THE THREE GRACES I
Watercolor on paper, 9 × 12" (23 × 31 cm).

Four values of Hooker's green, plus a very pale fifth, representing the white of the paper, combine to produce a monochromatic painting rich in contrasts between light and shadow.

Exercise: PAINTING A THREE-COLOR PEPPER IN SIX STEPS

STEP 1 Draw the foreground fryer pepper from the previous exercise, using your 2B pencil on watercolor paper. This time, instead of one color, you'll use three: aureolin (a pale yellow), Hooker's green, and burnt sienna.

STEP 2 Apply liquid mask (shown here in orange) where the highlights will go. Refer to the earlier photos and value drawing of the pepper as a guide. Note that the cast shadow should be part of your drawing.

STEP 3 Wait until the liquid mask is completely dry. Then, with your No. 6 round brush, paint a thin wash of aureolin over the pepper as an underglaze. Let it dry.

STEP 4 Glaze in lighter areas with a diluted, pale Hooker's green over the yellow. Capture the curves by having your brushstrokes follow their contours.

STEP 5 Make test strokes next to your pepper as you dilute paint. Now mix diluted Hooker's green with burnt sienna to get an olive green. Begin to paint shadows with olive green. Soften their edges with clear water or a tissue.

STEP 6 Paint the cast shadow with diluted olive green. On the pepper, add more yellow to intensify some lighter areas. Add more Hooker's green for darker areas, especially where the pepper rests on and meets its cast shadow. Test paint in little swatches off to the side as you work.

Student Gallery: MONOCHROMATIC PEPPERS

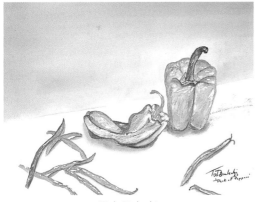

Tish Bialecki
PECK OF PEPPERS
Watercolor on paper, 12 × 16″ (31 × 41 cm).

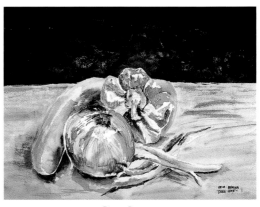

Reva Berger
STILL LIFE
Watercolor on paper, 11 × 15″ (28 × 38 cm).

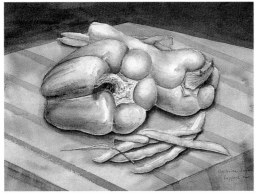

Svetlana Aniskina
PEPPERS
Watercolor on paper, 9 × 12″ (23 × 31 cm).

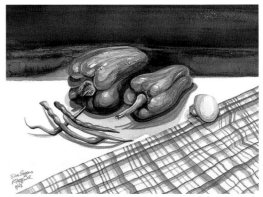

Kathleen Fitzgerald
BLUE PEPPERS
Watercolor on paper, 12 × 16″ (31 × 41 cm).

Softening Shadows

As you'll note in the student artwork above, many of the shadows have nice, soft edges. Whenever you paint shadows that you wish to diffuse gently into areas that surround it, employ the easy technique shown here.

To soften a shadow, paint a stroke with plenty of color. Rinse your brush. Paint a clear stroke of water away from the first stroke, with a space between the two. Dip your brush in clear water, wipe on a towel. Connect the two strokes to produce a variable flow of color from light to dark.

Elizabeth Horowitz
JANE'S BARRED ROCK CHICKENS
Watercolor on paper, 30 × 22" (76 × 56 cm).

Light reveals texture in this painting. Also note how chiaroscuro, the technique of modeling forms with light and shadow, animates the scene and gives it a three-dimensional illusion.

Composition & Perspective

Now that you have a sense of basic watercolor techniques, colors, values, glazing, patterns, light, and shadow, it's time to turn to the thing that holds all those elements together: composition. *Good* composition results when all the pieces add up to a harmonious entity, producing an appealing painting. To make that happen, the artist must balance all those abstract tools like a juggler.

A well-composed painting has carefully arranged forms, shapes, and edges; a balance of color and tonal values; and a foreground, middle ground, and background that merge harmoniously. The forms, lines, and/or shapes lead the eye around the two-dimensional picture plane. In a well-composed painting, the eye is drawn to the focal point first—the heart of the painting. Then it moves around, exploring the rest of the picture. It's the artist's job to establish that center of interest when composing the painting, and for maximum impact, to keep all unnecessary details edited out.

How do we know where to place the center of interest? Many artists are guided by the *Golden Section,* or *Golden Mean,* a mathematical theory formulated about two thousand years ago. Simply stated, for a watercolor painting, you rule a rectangular sheet of paper with one vertical line and one horizontal, placed at certain spots, to divide the sheet into four sections of unequal size. The proportions of the four sections are said to be in perfect harmony: The smaller part is to the larger part as the larger part is to the whole. Where the two lines intersect is where the painting's center of interest should be located. Placing the strongest elements and greatest value contrasts to the right or left of those intersecting lines often works best. Artists refer to that as the "classic cut," or "just cut."

Elizabeth Horowitz
LEMONS
Watercolor on paper,
11 × 7″ (28 × 18 cm).

Viewfinder

Another tool to aid in composing a painting is a viewfinder. The simplest and handiest viewfinder is an ordinary photographic slide mount. With the film removed, it functions as efficiently as an expensive viewfinder device or a camera lens. Hold the mount up to the subject or scene you wish to paint. What you see through the window of the slide mount establishes the boundaries of your composition. Move the window around until you find the best borders for your picture: where you want to cut off the scene at top and bottom, left side and right side. In making that decision, take into account where the focal point will be placed. Try to pinpoint what stimulated the emotional response that led to your selection of that particular subject matter. Zero in on that attraction and feature it compositionally while employing the other fundamentals. For example, in a landscape, which is more important to you: the sky, the foliage in the foreground, the mountains in the background, or perhaps a particular color or colors at a certain spot in the scene? Which do you want to feature? Perhaps change the angle of view. How you plan your composition will greatly influence the impact of your statement.

There is no substitute for "prep" work. Taking the time to plan your composition is just as important as doing a value sketch in pencil before going on to paint in watercolor.

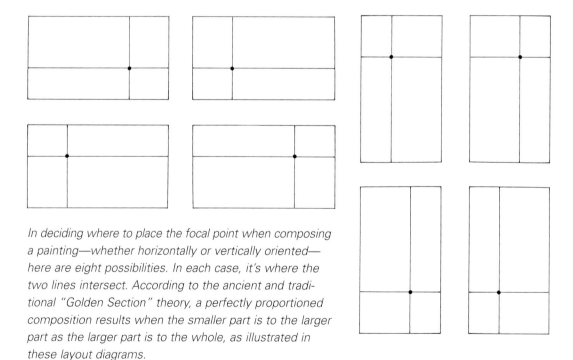

In deciding where to place the focal point when composing a painting—whether horizontally or vertically oriented— here are eight possibilities. In each case, it's where the two lines intersect. According to the ancient and traditional "Golden Section" theory, a perfectly proportioned composition results when the smaller part is to the larger part as the larger part is to the whole, as illustrated in these layout diagrams.

Active Versus Static Composition

Never cut a painting in half. A landscape's horizon will convey more interest and better composition if it is placed either above or below a central line. Halves are equal, static, and boring!

To depict a peaceful scene, keep the composition's lines horizontal. But to lend active, dynamic energy to a scene, add diagonals. A fine example of that principle is Andrew Wyeth's *Christina's World*," in which a meadow forming the horizon line of the painting tilts uphill to the right, instead of going across in a straight line. As in that case, diagonals generally lead the eye around the picture and yield a more vital composition.

Foreground and Background

When planning a landscape, both foreground and background are essential elements in showing the viewer the depth of a three-dimensional scene on a two-dimensional sheet of paper. Foreground is what appears to be nearest the viewer; it's always at the bottom of the composition. Background is what seems to be farthest away; it's placed at the top of the composition. Middle ground is what happens in between, but often, it's so subtle that foreground and background just seem to merge.

SHAPES on a picture place are like pieces of a jigsaw puzzle. They create the steps that lead the eye from near to distant places in the scene.

COLORS and their temperature category also must be thought out carefully. Cool colors—purples, blues, greens—recede and imply distance. Background mountains painted in pale, cool colors tell us they are far away. Warm colors—reds, oranges, yellows—advance and seem to come toward the viewer.

EDGES must also be considered. A hard-edged object belongs in the foreground. The sharper the edge, the closer the object will seem to be in the composition. When you give a soft edge to an object or a group of objects, such as a row of bushes, it implies they are behind foreground objects, receding into the distance.

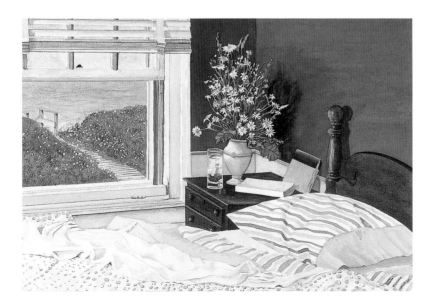

Elizabeth Horowitz
SUNDAY MORNING
Watercolor on paper,
15 × 22" (38 × 56 cm).

This painting's composition is based on a diagonal line from the edge of the bedsheets to the nightstand, which leads the viewer's eye out the window to the focal point: the path toward the beach.

Perspective

Perspective in art is the representation of three-dimensional subject matter on a two-dimensional surface, as seen from the vantage point of the viewer. Numerous volumes have been written about perspective. But since its complexities are beyond the scope of this primer, we'll touch on only those three terms that are most useful for you to know as a beginner watercolorist: one-point perspective, vanishing point, and horizon line. The three connect in this way: *One-point perspective* is when the viewer's eye is drawn toward a single *vanishing point* where all lines converge on the *horizon line*.

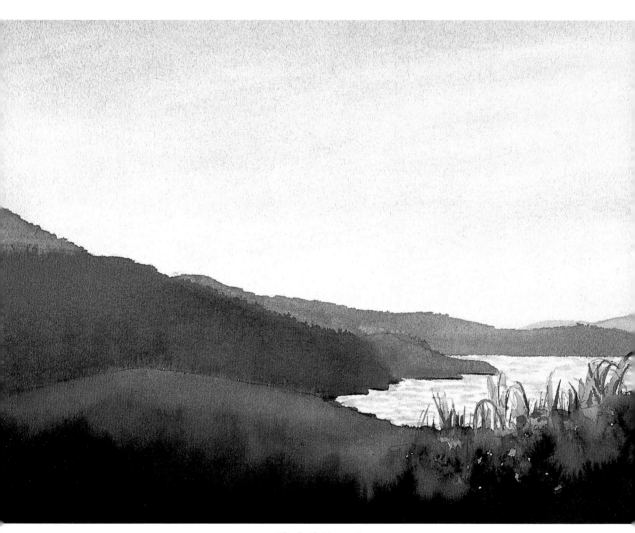

Elizabeth Horowitz
BAY VIEW, VIRGIN ISLANDS
Watercolor on paper, 10 × 14" (25 × 36 cm).

The vanishing point in this landscape painting, in the far-right corner, is where the mountains in the distance recede and almost disappear, or vanish, from sight.

HORIZON LINE in landscape is the imaginary line where the sky and the earth seem to meet. Drawing the horizon line is the first step in establishing perspective. In seascape, the horizon is where sky meets water. In still life, it's where the foreground, usually a table, meets the background. In landscape, cityscape, or seascape, a low horizon line features the sky, whereas a high horizon places emphasis on the land, the buildings, or the sea.

VANISHING POINT, where objects converge in the distance, can seem so far away that as objects recede and get smaller and smaller, they finally just disappear.

Viewpoint

When composing a painting, varying your angle of view is often enough to create a fresh, personal interpretation. Avoid symmetry. And instead of drawing your subject head-on, try another angle: from one side, or looking down at a subject from an overhead view, or sitting down and looking up at a subject. Bring variety to your format as well. If you find yourself inclined to compose only horizontal compositions, especially when painting landscape, change to vertical. If you usually start with your paper oriented vertically, try horizontal next time. Experiment with square and oval formats.

Movement

You can suggest movement in a painting by capturing a "moment of rest" in your composition, when an action seems to be frozen in space.

Maybe it's the foliage of a tree, blowing in the wind, depicted just at that moment when the arc of the curved branches tells the viewer there's movement in the air. We see that often in sports photos—that instant captured on film when the baseball player's bat reaches its farthest point in the arc of his swing. See if you can capture a similar "moment of rest" to emphasize a message of action or motion in a composition.

COMPOSITION TIPS

- Select a viewpoint: straight ahead, from the side, or an aerial view?
- Choose a format: horizontal, vertical, square?
- Make your focal point the area with the highest value contrast.
- Design the primary shapes to be an abstractly exciting composition.
- Avoid symmetry.
- Create movement with diagonals or a "moment of rest" in your composition.
- Differentiate foreground from background.
- Keep your foreground in sharper focus, with harder edges.
- Make the background less focused, with softer edges.
- Bring objects forward by painting them in warm reds, oranges, and yellows or darker.
- Push selected items back by painting them in cool violets, blues, and greens or use paler values.
- Include highlights and shadows in your composition.

Exercise Preparation

The goal of the next exercise is to learn how to use photographic reference as your subject matter—*but* the aim is *not* to copy a photo exactly. Instead, edit and alter composition and/or perspective for greater impact and individual statement. Eliminate nonessentials and focus on parts of the photo that interest you most. A reference photo or even a scene painted from life rarely has all the elements intact exactly as you wish to depict them. A story is told about French Impressionist Paul Cézanne, who was painting on site when a passerby admired his canvas but protested, "Where is that tree? I don't see it out there!"—to which Cézanne replied, "It's back down the road a bit!"

Exercise: BARN IN A LANDSCAPE

STEP 1 Study this color reference photo, featuring a barn, tree, and hay wagon. Use all three elements or eliminate one or two. Consider repositioning objects. Would you like to move the barn closer, farther away, or to the other side of the composition? Maybe change the size or color of the barn? Perhaps fill the wagon with bales of hay—or eliminate the wagon altogether? Maybe add more trees or change their scale?

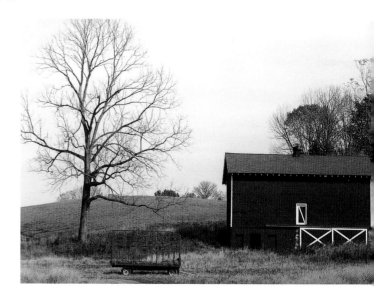

STEPS 2, 3 Whenever your reference material is in color, make a black-and-white photocopy of it to help you see values more readily. Using the photocopy as reference, compose the scene on sketch paper. Add tonal values with your No. 2 pencil. Make a five-tone value scale, from dark to light—the lightest being the white of the paper.

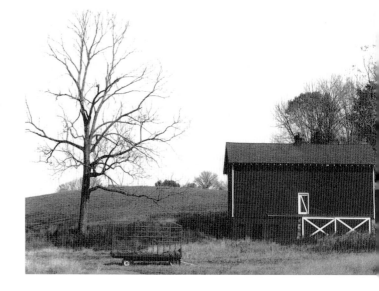

STEP 4 Transfer your sketch to watercolor paper as a line drawing. When satisfied with your composition, decide where your center of interest will be. Does the composition lead the viewer's eye to that focal point? Perhaps add a road or a fence to help. Check that the horizon line, where sky and land meet, does not cut the paper in half. Add or subtract details to the barn, such as a door, more windows, siding detail, or a weathervane.

STEP 5 I've used orange and green to show where I use liquid mask. Apply liquid mask to the areas that you want to save as white, such as white trim on the barn, highlights on tree trunks and some branches, sun glints on foreground grasses. Let the liquid mask dry thoroughly. In the meantime, try to get a mental picture of how you want the painting to look. What season is it? What color scheme characterizes that season? It's OK if your barn looks crooked or the roof slopes. Barns can be that way. What about your light source? If you want light to come in from the right, things will have cast shadows on the left side. Lightly pencil in a removable arrow as a reminder of your light source. Now decide on your palette. The color tips on page 78 are for an autumn scene.

COLOR TIPS FOR COMPLETING YOUR PAINTING

- Sky: ultramarine blue plus burnt sienna (my "Dynamic Duo")
- Trees, trunks, and limbs: burnt sienna and ultramarine blue
- Tree foliage: aureolin yellow, burnt sienna, alizarin, yellow ochre
- Barn siding: cadmium red with a touch of sepia
- Barn roof: burnt sienna plus ultramarine blue to equal gray
- Pasture: Hooker's green and aureolin yellow
- Foreground meadow hay and grasses: aureolin yellow, yellow ochre, Hooker's green, burnt umber; burnt umber with sepia for a darker brown

PROCEDURAL TIPS FOR COMPLETING YOUR PAINTING

- Prop your paper up at a 30-degree angle. Spray your palette to moisten or activate your paints.
- Work background to foreground. Paint the sky first.
- Be sure to leave liquid mask in place while you paint.
- Paint the distant pasture and trees.
- Paint the overall color of the barn. Let it dry, then glaze on a second coat, using the drybrush technique, which is great for weathered barn siding.
- Add details of the barn siding after the main color has dried.
- If you included the hay wagon, paint that next.
- Paint the foreground meadow and grasses. Let your brushstrokes follow the direction of growth.
- Remove liquid mask from the tree trunk. Paint the trunk and some limbs (if your tree is to have leaves).
- If your tree is leafless, brush in all the limbs to capture the silhouette of the tree (a full crown of branches). Add a touch of burnt umber to suggest a few leaves still clinging to the tree.
- Paint limbs and branches thinner as they grow higher. Let them dry.
- Sponge in some foliage on the large tree, or brush in some yellow in patches to give the look of foliage clumps. Let it dry, then sponge in a few darker foliage colors. Take it easy with the sponge— don't overdo it. Turn the sponge to different angles to avoid a "potato stamping" look.
- Refer back to your pencil value sketch to see if your paint values correspond to it. If too light or dark in certain areas, adjust your paint.
- Refer to your arrow that indicates light source, and add shadows accordingly.
- There is usually a dark shadow under the eaves of a barn. Paint a good dark shadow there, then soften its lower edge with a brush of clear water or a tissue.
- Remove any liquid mask that remains. Add color as needed (such as the fence, road, grasses, hay). Soften some edges where liquid mask was placed and adjust whatever you feel needs correction.
- Sign your work, smile, and congratulate yourself on a job well done!

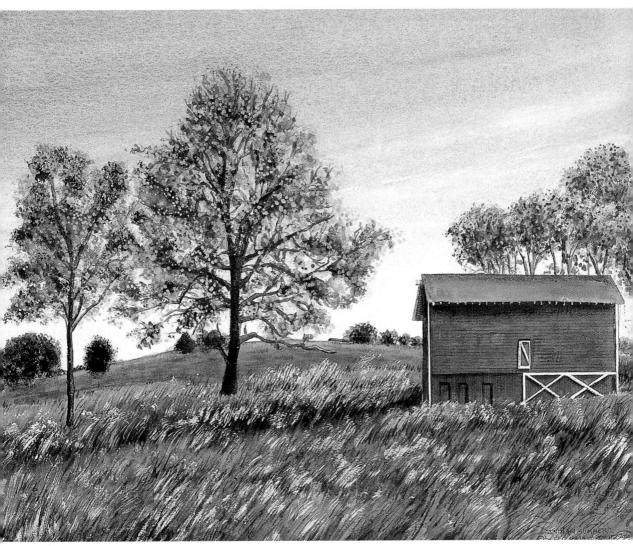

Elizabeth Horowitz
INDIAN SUMMER
Watercolor on paper, 21 × 24" (53 × 61 cm).

In my painting, I added a second tree and placed more trees on the horizon than were in the photo reference. I deepened the foreground and emphasized the slope by making the barn's shadow run on a diagonal.

Student Gallery: BARN IN A LANDSCAPE

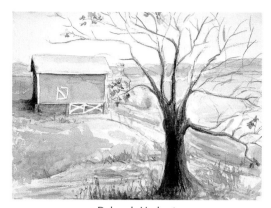

Deborah Herbert
MOUNTAIN FARM
Watercolor on paper, 12 × 16″ (31 × 41 cm).

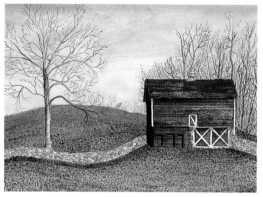

Jill Vondervor Frank
BARN IN AUTUMN
Watercolor on paper, 10 × 14″ (25 × 36 cm).

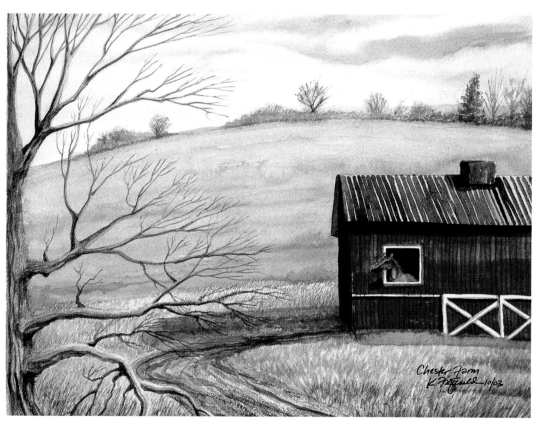

Kathleen Fitzgerald
CHESTER FARM
Watercolor on paper, 12 × 16″ (31 × 41 cm).

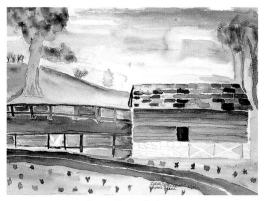

Ilene Oppenheimer
RURAL SCENE
Watercolor on paper, 10 × 14″ (25 × 36 cm).

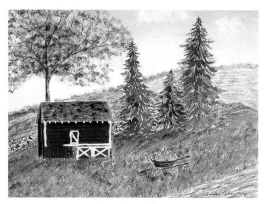

Carolyn Nelson
FALL HARVEST
Watercolor on paper, 12 × 16″ (31 × 41 cm).

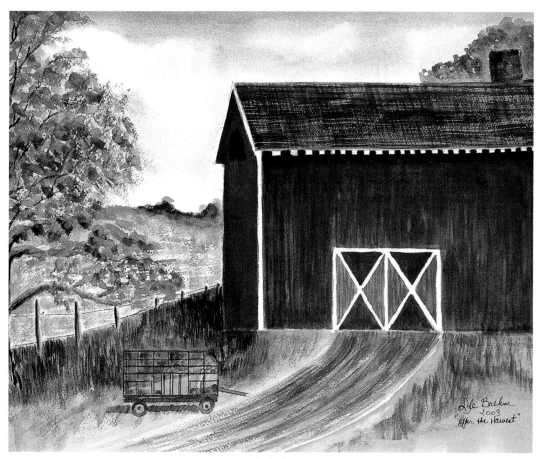

Lyle Brehm
AFTER THE HARVEST
Watercolor on paper, 12 × 15″ (31 × 38 cm).

Positive & Negative Shapes

I n composition, the terms *positive* and *negative* refer to shapes and their surrounding areas. All the spaces that separate the objects' shapes—the areas around and between objects—become negative shapes. For example, a flower's petals and leaves are positive, foreground shapes. The areas between the leaves and the spaces that separate leaves from blossoms are all negative, background shapes. The contrast and interaction between the two can carry a painting.

In planning a composition, it's as important to consider the spaces that come between objects as it is to plan the objects themselves. How you lead the viewer's eye in and around an object can make the difference between a boring, static painting and an exciting, active one. Edges also play a big role in positive/negative design. If all the edges are hard, there is no subtlety; if all the edges are soft, there is no contrast. Try to strike a balance between the two.

Contrasting values or color intensity also impact on the relationship between positive and negative shapes. Think of a black-and-white checkerboard. All the shapes are equal squares. Which stand out more? The black or the white? The black appears to recede to the background. The white advances to the foreground. We see the same positive/negative relationships in nature.

Since trees and florals are popular subjects for watercolorists, and future chapters deal with both, the exercises in this chapter concentrate on painting leaves. The empty spaces around and between leaves can contribute shapes to a painting that are as vital as the leaves themselves. In fact, even when a tree is bare, the negative spaces separating its limbs and branches can become the focal point of a composition. In my painting on the opposite page, the positive shapes are the limbs and branches, formed by the white of the paper. The negative shapes are the spaces among those limbs and branches. I've heightened those negative spaces by painting them in a rainbow of warm and cool hues to emphasize the vitality of their shapes.

Elizabeth Horowitz
TREE OF LIFE
Watercolor on paper,
14 × 10″ (36 × 25 cm).

Studies for Leaf Shapes

The lively and varied shapes of leaves make interesting and instructive subject matter for watercolor studies. Use the reference photos on these pages for inspiration, or collect your own leaves for models. Take a walk in your local park, woods, or your own backyard.

Gather leaves of different types, sizes, and shapes from plants and trees. Collect acorns, pine cones, pine needles, or whatever appeals to you. Leaves from one type of plant can be used, as long as their sizes are varied. Autumn leaves make particularly awesome subject matter.

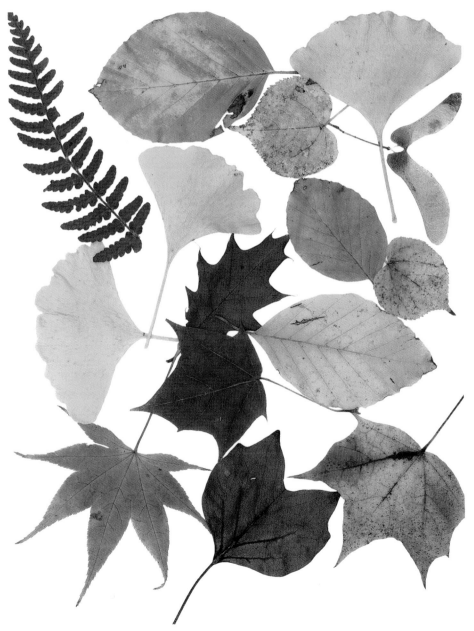

This mélange of leaves offers a variety of appealing positive and negative shapes.

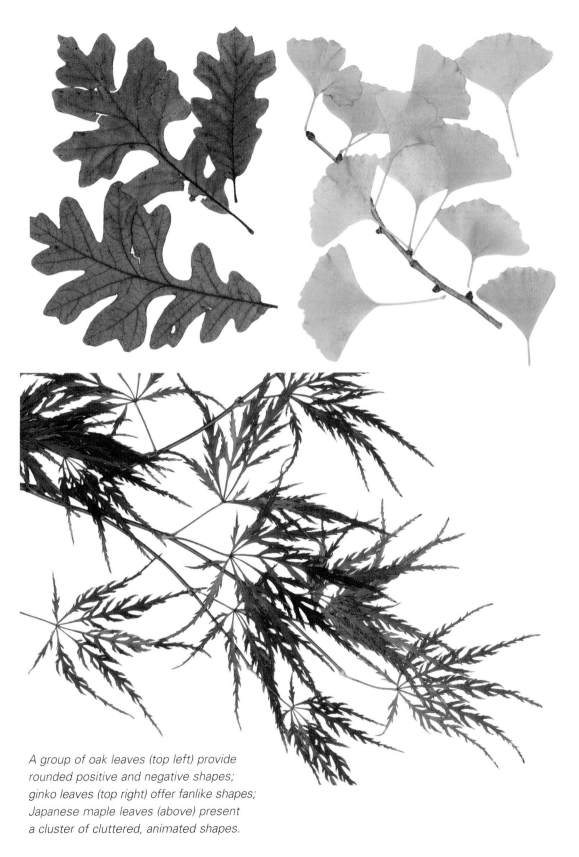

A group of oak leaves (top left) provide
rounded positive and negative shapes;
ginko leaves (top right) offer fanlike shapes;
Japanese maple leaves (above) present
a cluster of cluttered, animated shapes.

Techniques for Painting Leaves

Before you begin composing your leaves painting built around positive and negative shapes, here are some additional techniques to help portray leaves realistically.

Wet-in-Wet Plus Scoring

Paint some leaves wet-in-wet. Begin by drawing a leaf. Wet it with clear water. Wait for the shine to go away. Drop in another color and let the paint and watercolor paper "do its thing."

To add veins to other leaves, first cover the leaf with a base wash, and while it's still wet, but the shine has gone away, score the veins with the back end of a brush. The color will flood into the scored lines like water in a riverbed. The color of the vein will be darkest in value.

Lifting Color

On some leaves, the veins of the leaf may be lighter in value, rather than darker. When that's the case, paint the leaf as desired. When it's almost dry, use a clean, thirsty brush to lift the color.

Rinse the brush in water and blot it on a paper towel. If you still want the color even paler, repeat above. Let it dry, then add the proper color to the vein.

Spattering

Spattering creates a fine spray that adds texture. Where leaves have blotches, simulate them with spattering. It's also a great technique for suggesting the dirt on a forest floor.

First, practice on scrap paper. Dip an old toothbrush in paint. Rub your thumb over the bristles to create a mist of tiny dots. Another way to spatter is on a painting that's still a *little* wet. Dip a No. 2 round brush in paint, and hold it horizontally over the art. With your other hand, tap the metal ferrule of the brush to spatter color on the art. The mist flows onto the paper and bleeds. It should look like fireworks or confetti when the paper is wet. When using this technique on final art, protect your work area and parts of your painting not to be spattered by covering them with scrap paper while you work.

COLOR TIPS FOR PAINTING LEAVES

- Have colors premixed on your palette in ready-to-go batches of varied values.
- Work with intense, but transparent (not opaque), colors, such as aureolin yellow, gamboge, Hooker's green, ultramarine blue, alizarin, burnt sienna.
- Mix lively greens by blending different yellows and blues.

- Avoid using green straight from the tube. For example, add a touch of alizarin to Hooker's green.
- Explore the use of complementary colors such as reds and greens.
- When painting autumn leaves, always incorporate warm yellows, oranges, and earth-tone umbers and ochres.

Over a pale wash of aureolin yellow, I scored the leaf's veins with the back end of a brush. Then I put a mid-value burnt umber in the scores and let it run and diffuse into the yellow. When that dried, with the fine point of a No. 2 brush dipped in darkest-value burnt umber, I defined the veins clearly.

Spattering with a toothbrush (left) on dry paint, or with a round No. 2 brush (right) on moist paint adds realistic touches of texture to leaves.

To lift color and add a light vein, I drew a leaf, painted it yellow, and let it dry. Then I glazed over it with burnt sienna. After rinsing and drying my brush, I stroked over the burnt sienna and lifted the color to create light veins.

Elizabeth Horowitz
FOREST FLOOR FOLIAGE
Watercolor on paper,
22 × 30" (56 × 76 cm).
A natural combination: The medium of watercolor and the subject of autumn leaves make perfect partners.

Positive-Negative Leaf Painting

Place the leaves you've collected on watercolor paper. Use all the paper; don't just plunk the leaves in the center. Spread them around to form an interesting composition. Include strong negative shapes. Lead the eye around the composition with a curving stem or diagonals. Perhaps let some leaves overlap; let others cut in from outside the paper's edges. Trace the leaves with a No. 2 pencil. (Don't press hard on fresh green leaves; they may stain your paper.) Turn your drawing upside down. It's a good way to see if your composition is well balanced and unified.

When you assemble your materials to complete your painting, good news: No liquid mask needed here! (Nobody loves the smelly stuff, but as you've seen with previous exercises, it can be a great aid.) Another departure from previous procedures: Background will be painted last, not first.

TIPS FOR COMPLETING YOUR PAINTING

- Begin painting positive shapes, the leaves, with your lightest colors first. It bears repeating: Always work from light to dark.
- Paint negative shapes (background) last.
- Have fun with colors. If an autumn leaf is turning from green to red, blend the two colors on your paper. Paint green on one part of the leaf. Rinse your brush. Apply red on the other part, farthest away from the green. Work the red into the green with one stroke so the colors bleed together, diffusing gently.
- When the shine goes away, drop in some spots of red and green.
- Skip around your paper as you paint leaves, completing all the positive shapes. To get hard edges, don't paint leaves next to each other while still wet.

- For greater visual interest and color brilliance, blend the paints on your paper, not on your palette.
- For added textural accents, use granular colors: cerulean or ultramarine blue and burnt or raw umber.
- Now paint the background, all negative areas around the leaves. In deciding the color or colors to use, consider the angle of view you intend to create.
- Is the viewer looking down on a pile of leaves on a dark forest floor?
- Is the viewer looking up at tree branches with a blue sky peeking through?
- Choose, mix, and paint color—an intense blue sky or dark soil—accordingly.
- When your painting is dry, sign it, and leave a margin for a mat and frame.

OPPOSITE TOP: Elizabeth Horowitz
FOREST FLOOR WITH OAKS AND SASSAFRAS
Watercolor on paper, 22 × 30" (56 × 76 cm).

OPPOSITE BOTTOM: Elizabeth Horowitz
FOREST FLOOR WITH ACORN
Watercolor on paper, 30 × 42" (76 × 106 cm).

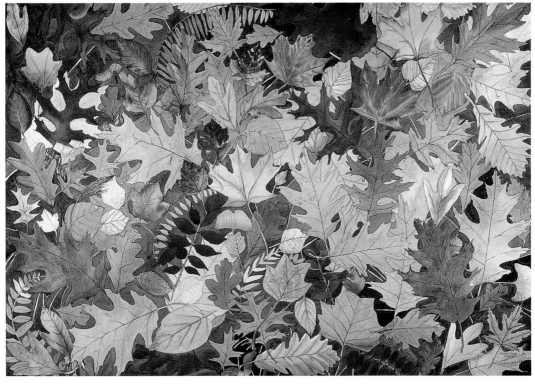

Student Gallery: POSITIVE-NEGATIVE LEAF PAINTING

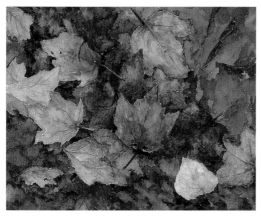

Beverly York
AUTUMN GLORY
Watercolor on paper, 10 × 14" (25 × 36 cm).

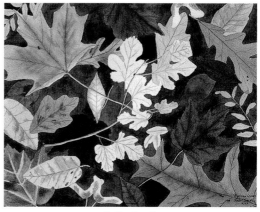

Sallie Smith
AUTUMN LEAVES
Watercolor on paper, 12 × 15" (28 × 31 cm).

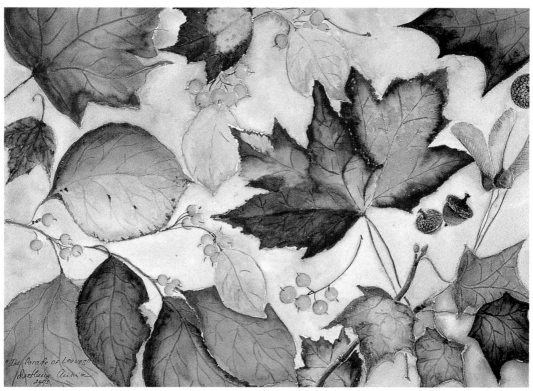

Svetlana Aniskina
THE PARADE OF LEAVES
Watercolor on paper, 10 × 14" (25 × 36 cm).

Carola McAndrew
FALL LEAVES
Watercolor on paper, 7 × 11″ (18 × 28 cm).

Linda Levi
LEAVES
Watercolor on paper, 11 × 15″ (28 × 38 cm).

Audrey Bartner
FALLING LEAVES
Watercolor on paper, 10 × 12″ (25 × 31 cm).

R. Mal Schwartz
LEAVES
Watercolor on paper, 22 × 15″ (56 × 38 cm).

91

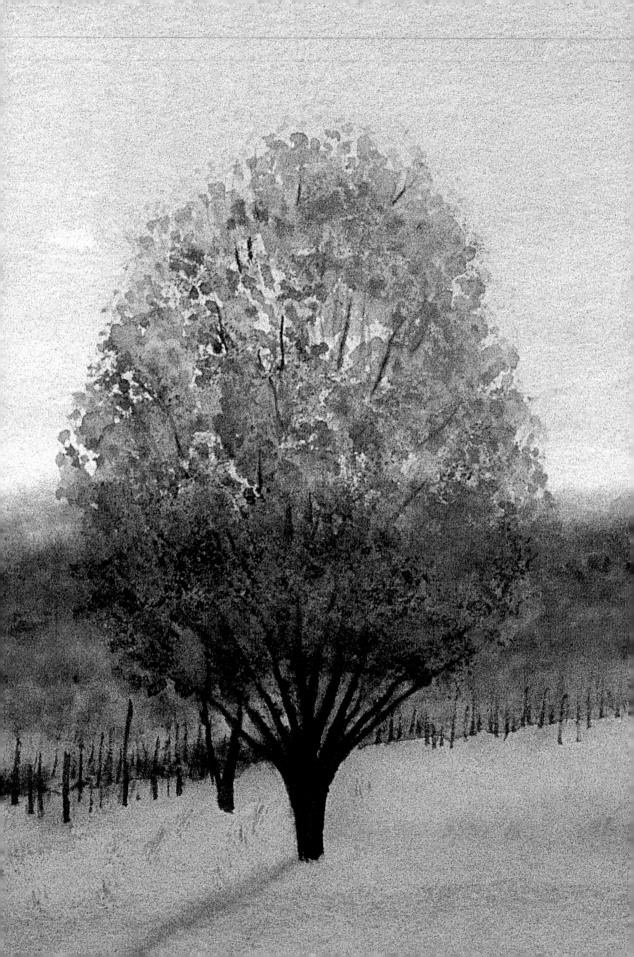

Skies & Trees

The natural flow of watercolor paint lends itself beautifully to portraying the flowing rhythms of skies and trees. Landscape artists must know how to master laying in a sky and painting various kinds of trees. Skies set the tone, time of day, and atmosphere of a scene. Trees can suggest the season and climate of a setting.

Whenever you're outdoors, start observing skies and trees more carefully. It will increase your visual awareness and enable you to translate into paint whatever you see around you. You don't have to become a meteorologist or a botanist; just be more *observant*. Skies and trees should be painted using different techniques to express their individual qualities. Let's concentrate on skies first.

The first thing to do when painting a sky is establish your horizon line, so you'll know how much space to give to the sky. Compositionally, the more space you give to the sky, the more emphasis it will have in your picture. Once you move the horizon line up, appropriating less space for sky, emphasis will fall on the trees, fields, and/or other landscape elements. Decide which you prefer to feature as your subject matter—sky or land—before placing a horizon line.

Graded Wash for Gentle Skies

In painting a sky, note that it's usually darker and more intense in hue at its zenith, its highest point. Most noticeable when there are no clouds, a clear, gentle sky becomes lighter or less intense in hue at the horizon. Expressing this gradation of color intensity in the sky calls for a graded wash. It's best to start darker at the top of your paper and work lighter in color and value as you go downward. However, if you find it easier to work from light to dark, turn your paper upside down and place lightest values at the horizon, adding more pigment as you work toward the top edge of the sky with a graded wash. Whichever way you choose, skies, like backgrounds, should always be painted first before trees or other landscape elements are added.

Elizabeth Horowitz
**FOUR SEASONS
(DETAIL: SPRING)**
Watercolor on paper,
22 × 15″ (56 × 38 cm).

Wet-in-Wet for Active Skies

When you put wet paint on wet paper, the finished look is a sky with spontaneity and movement, spreading energy to the whole scene. Combining touches of graded wash with wet-in-wet technique in one painting adds even more vitality. Practice your wet-in-wet skies in small studies first. When you're ready for a full painting, use 140-lb paper. Anything lighter is apt to buckle. Begin by wetting your paper with a wide, flat brush, or spray a gentle mist on the sky area. Don't flood the paper with too much water, or even a heavy paper will buckle. Remember: Less water equals more control.

Premix colors on your palette. Wait for the wet paper to lose its shine, then work quickly, before the paper dries unevenly. While your paper is drying, put color on the entire sky and let it flow, bleed, and diffuse. Keep your brushwork to a minimum. The beauty of watercolor is one sure stroke. Resist the temptation to go back and touch up colors, which will cause a "blossom"—a spidery, mottled look.

Sky Colors

Skies appear blue because of the way light passes through the earth's atmosphere. For the loveliest, most realistic, true-blue watercolor skies, the best pigments are ultramarine, cobalt, cerulean, and Prussian blue. When using ultramarine and cerulean—both being granular pigments that produce a mottled texture—add a touch of cobalt to extend and even out the paint.

But skies don't have to be blue. Paul Gauguin, among other dynamic artists, took great liberties with sky coloration and scored high on impact as a result. Your sky may be violet, orange, or pink, depending on the aura you wish to convey. Color temperature should also be considered to coordinate the season with an appropriate sky. The selection of color can convey the message dramatically or lose it. Hot summer days, cold winter weather, and storms at sea all produce different sky colors. Whichever ones you use should coordinate with the entire painting for color harmony. Vincent Van Gogh often put touches of landscape colors in his sky to unify a painting.

When a watercolor sky has various colors, such as a yellow, orange, and pink sunset, it can be tricky to paint. But don't be daunted; simply plan ahead. For example, because of watercolor's transparent nature, a yellow sun in a blue sky will turn green if you're not careful. Avoid that by leaving the sun area and some other parts of the sky white when you apply your initial blue wash. When that wash dries completely, paint the yellow sun. In other white areas, put yellow down and when it's dry, glaze over it with orange or pink for dramatic effect. Keep your strokes minimal when glazing, and remember my caveat: Don't "windshield wiper" with your brush.

Graded-wash sky: Work from the top down on dry watercolor paper, using a large, round brush. Paint a stroke from left to right. Dip your brush once in water and paint a second stroke from right to left. Dip your brush twice in water, wipe, and paint a third stroke, left to right. Dip the brush three times, wipe, paint another stroke, right to left. Rinse your brush well and paint using clear water down to the bottom of the sky area. In a painting, these palest tones would reach the horizon line, where sky and land meet.

Elizabeth Horowitz
AURORA BOREALIS
Watercolor on paper, 4 × 7" (10 × 17 cm).

Wet-in-wet sky: On wet paper with the shine gone, I brushed on my premixed colors, working quickly, before the paper dried. I allowed the colors to flow and diffuse, and let the white of my paper come through in some areas. By dropping in the paint on a diagonal, the sky takes on added movement.

Elizabeth Horowitz
AERIAL BALLET
Watercolor on paper,
6 × 6" (16 × 16 cm).

Graded wash with reserved areas:
This was a very impromptu painting. First, I placed liquid mask on areas where I wanted to include birds. After the mask dried, I laid in the sky with a graded wash. Before the sky was dry, I painted the pale violet, and let it diffuse gently on the horizon line. Once everything dried, I removed the mask and painted in the birds.

Clouds Enliven Skies

Clouds are an appealing part of a painted sky. Since there are many types of clouds, first consider their shapes and placement. As a guide, the name of a cloud describes both its appearance and height above the ground. For example, cirrus, the highest clouds, are very wispy. Cumulus are lower clouds that have a flat base and round outlines, often stacked up like a mountain. Nimbostratus are the dark, low, layered gray clouds that produce rain or snow. Even though clouds have those different characteristics and an infinite variety of shapes, most people paint them all as cotton balls. Avoid that. Remember when you were a child lying on the grass, gazing up at clouds and delighting in seeing a camel shape, a face, a violin? Observe clouds with those spirited eyes again and paint their fascinating forms. Notice how clouds are smaller at the horizon, larger higher in the sky—with hard edges on the bottom and soft edges on top.

Elizabeth Horowitz
SILO AT SUNSET
Watercolor on paper,
14 × 10" (36 × 25 cm).

For this sky, I wet the paper and painted the blue area first, then turned my paper upside down and dropped in yellow near the horizon, then orange, until it met the blue and turned gray.

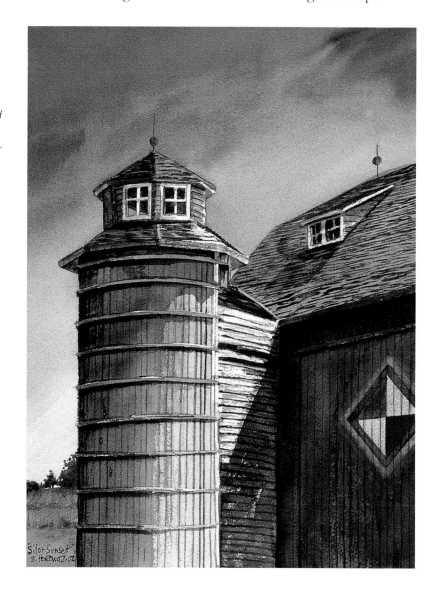

Cloud Techniques

Watercolorists have the advantage over oil painters when depicting cloudy skies, since the white of the paper can help so much in creating them. The most obvious way is to sketch the clouds in lightly with pencil, then paint the blue sky around them, using a wet-in-wet technique.

Another way to save the white of the paper for clouds is by applying liquid mask. However, mask leaves very sharp edges, and clouds have soft edges. To overcome that problem, soften the edges after the mask is removed, as instructed earlier (see page 30).

When you want to paint clouds that aren't completely white, for example those low, layered gray clouds, use blue mixed with its complement orange for the grayish tones. For a purplish cast, add red to blue. Some artists touch their clouds with other colors to unify them with the painting's overall palette. Try some experiments like that.

To "pop out" these clouds, first I painted the sky with a nonstaining color (cerulean blue). While it was still wet (but after the shine had gone), with a tissue wrapped around my finger, I wiped up the sky in a circular motion to form the clouds. To avoid rubbing color back on the paper instead of lifting it, I used fresh tissue as needed.

I started this sunset with a graded wash of sky color at the top. Then I dipped my brush in water, wiped it, applied more strokes, dipped and wiped again. When the brush reached the bottom, it carried only clear water. When the paper was dry, I brushed on diluted washes of yellow and red to complete the sunset aura.

To create sunlight streaming through clouds, before the wash was dry, I dipped my brush in water, wiped it, then made diagonal strokes. Repeating the process a few times, the brush picked up enough color to achieve this effect.

TIPS FOR PAINTING SKIES

- Test your premixed colors on scrap paper before going to watercolor paper. Is the value too dark or too light?
- Mix paint to cover the whole sky.
- Work from the top down. The sky is darkest in value at its zenith, lightest at the horizon line.
- Apply color all the way to the edges of your paper.
- Be sure to have your paper propped up at a 30-degree angle to facilitate the downward flow of your paint.

Painting Trees

The most important aspect of trees for painters to study is their silhouette, or "mug shot." Look at my illustrations of deciduous and conifer trees to see how their outline shapes differ. While these silhouettes can only show the trees branching out to the left and right, in a watercolor painting, colors, values, and good drawing should give the tree a three-dimensional look for it to be a convincing picture of branches growing out from the center trunk in all directions. Think of a tree as broccoli: a tall stalk with clusters of florets, or foliage.

"Sky Holes"

In depicting a tree, it's also essential to include its "sky holes"—all those negative spaces among the branches and foliage where the sky peaks through. To paint a tree realistically, it is *imperative* to allow for those negative spaces. Another *must* is painting the foliage, the positive shapes, in at least two values of a green for the tree to have a lifelike look. Beyond that, it's the artist's choice to expand the palette with more values of the single green and/or add other colors.

Tree Trunks and Limbs

Light falling on a tree will make one side of the trunk darker than the other side and may cast a shadow on the ground. When drawing the base of a tree, note that it's rarely triangular, but more frequently straight. When a tree ages and the roots fan out, the base does appears slightly triangular, but only palm trees and some other tropicals usually have a slightly flared base. If you draw an elm tree's base flaring out, it will look like a naive drawing.

Some trees grow tall and thin, while other fan out low and flat, but limbs always grow out from all sides of the trunk and become thinner and more delicate as the tree grows upward. When a tree is foliated, the branches are only partially visible and should be painted not as continuous lines, but broken up into segments. Any brush that comes to a good point will do the job in painting the thinnest branches and twigs.

Deciduous trees such as these, from left, ash, oak, poplar, and beech, drop their leaves annually. With or without foliage, each has a distinctive shape to its structure. When a painting includes lots of trees, varying their species, colors, and shapes can breathe added life into your picture.

Conifers such as these spruce trees, firs, pines, and other species, have needles, not leaves, which present special challenges to the water-colorist. Never try to paint every single needle that you see. Edit. Suggest them in clusters, often growing upward on the limb, with needle points sticking out only here and there.

Bark Texture and Color

Trees have varying bark textures: Elms are smooth, oaks are rough, hickories are hairy. Drybrush is the technique to use for rendering rough-hewn textures. Birch trees have white bark with subtle markings. Paint them wet-in-wet and score their marks with an old credit card or similar rigid edge.

Trees are *not* brown; they are a neutral, mouse gray. They take on a darker, almost black, appearance when moistened by rain or snow. The ideal pigment mixture to capture this neutral gray is the "Dynamic Duo" that I extolled earlier—burnt sienna and ultramarine blue, mixed warm or cool depending on the proportions. I call burnt sienna the "Magic Mixer," as it transforms other colors into earth-toned neutrals without destroying their original color identity.

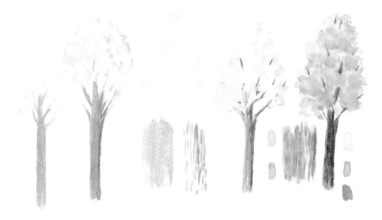

Foliage brushed on: Begin with burnt sienna and ultramarine blue—a wonderful gray for tree bark. Paint branches thinner as they grow higher. Dab on yellow to create foliage. Add drybrush touches on the trunk for texture; darken one side to suggest its cylindrical form. Add a darker value of color to the foliage.

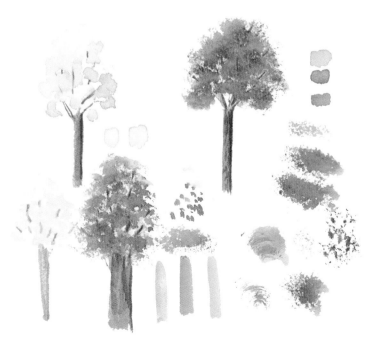

Foliage sponged on: First use a brush to paint a wash of light-value green to create clumps of foliage. Let them dry. Then dip a dry, natural sea sponge into a darker value of green. Stamp the sponge at the bottom of the foliage clumps. Twist your sponge in the air, not on the paper (like a potato stamp) to get varied textural impressions on the foliage—but don't overdo it.

Portraying Seasonal Trees

To capture the four seasons in water-color, let color do the work. As the landscape changes dramatically from season to season, the surest way to communicate nature's visual message is with the proper choice of colors.

WINTER colors are generally low in intensity, dotting the landscape with subtle earth tones. The sky is often a pale, cool gray. But when the sun comes out after a snowstorm, the sky can turn an intense blue. Conifer trees lend evergreen touches to an other-wise muted landscape.

SPRING is nature's rebirth. The vernal equinox brings stronger sunlight and a sky that can be a beautiful robin's-egg blue. As buds and blossoms burst forth, trees add their delicate foliage to the landscape. To depict spring foliage, incorporate sunny yellows and yellow-greens in your palette.

SUMMER brings the sun and light to its greatest intensity. Skies are vibrant, intense blues. Greens are rich and deep, not as yellow as spring greens. But vary greens for greatest eye appeal. Enhance some of your summer skies with clouds of interesting shapes.

AUTUMN puts on nature's most extrava-gant show, her final hurrah, treating us to a riotous display of rich, eye-catching color. The visual impact is at its height. Warm yellows, oranges, and reds resonate with greens and violets. Incorporate neutral grays to unify the palette. Autumn skies, less brilliant than summer's, are often gray.

Exercise Preparation

Your goal is to capture the essence of nature's many moods in color, by painting a pear tree as it looks in each of the four seasons. Work on your watercolor block vertically. (If you use a single sheet of paper, mount it to a board with masking tape along all edges.) Rule your sheet into four equal sections—a vertical rectangle for each season: Winter (top left); Spring (top right); Summer (bottom left); Autumn (bottom right).

Use this photo of the pear tree in winter as reference for all four seasons. But alter your drawing of the limbs and branches for each to allow for the differing seasonal foliage that you'll paint in later.

Exercise: A TREE IN FOUR SEASONS

STEP 1 Winter tree: Lightly sketch the first tree (upper left) on your prepared watercolor paper. Draw the branches thinner as they grow higher. Eliminate the road in the foreground and leave space below the trunk for the tree's cast shadow. Indicate mountains with light lines. Sketch the low thicket behind the pear tree.

STEP 2 Spring tree: In the upper-right quadrant, draw the tree trunk, copying the major limbs that you drew for the winter tree. But reduce the number of branches, and draw them as broken segments, to allow ample spaces for the lush, green foliage that you'll paint in later. Indicate the background thicket and mountains.

STEP 3 Summer tree: Place this drawing in the bottom-left quadrant. With foliage at its fullest, the branches are least visible, so reduce their lines to provide more spaces for the dense growth. The broken lines should get thinner as they climb upward. Use vertical lines for background thicket and curves of distant mountains.

STEP 4 Autumn tree: In the bottom-right quadrant, draw this tree almost as densely packed with branches as it was in your winter drawing. Many of these neutral branches will peak out from the brilliant autumn leaves that you'll be adding as you complete your painting.

TIPS FOR COMPLETING WINTER TREE

- Apply liquid mask to "hold the white" for snow on the ground and perhaps for some spots where it clings to the tree. Let the mask dry.
- With a No. 6 brush, paint your winter sky in a graded wash of pale gray— a diluted blend of "Dynamic Duo" ultramarine blue and burnt sienna.
- Premix four puddles of color for distant mountains: pale violet; Prussian blue; a "wine-bottle green" blend of Prussian blue and Hooker's green; and burnt sienna.
- Paint a band of pale violet at the top of the mountain range. While it's still moist, paint a blue band below it, then the green, then the burnt sienna.The four bands blend together to suggest distant mountains and woods. Paint the bands right over the trunk and branches, but blot up the color on the trunk with a tissue before it dries.

- With a No. 2 brush dipped in mid-value sepia, paint the lower tree trunks in the thicket, from the ground up. Darken the left side of the tree trunks with a darker value to suggest light coming from upper right.
- Paint the tree limbs with a dark "Dynamic Duo" blend, with a touch of sepia added to it. Make the branches thinner as they get higher.
- With the same mixture, when the trunk is dry, use the drybrush technique to suggest bark. Darken the left side of the trunk.
- Add a long cast shadow to the left of the tree in ultramarine blue with a touch of violet. Use a tissue to soften the shadow's edges on the snow.
- Using the same shadow color, perhaps add some footprints in the snow.
- With burnt sienna, drybrush a few twigs sticking up in the foreground.
- Remove the liquid mask, and your winter pear tree is complete.

Elizabeth Horowitz
THE FOUR SEASONS
Watercolor on paper,
22 × 15" (18 × 25 cm).

Study this detail (right) of the painting on the opposite page for a closer look at the brushwork applied.

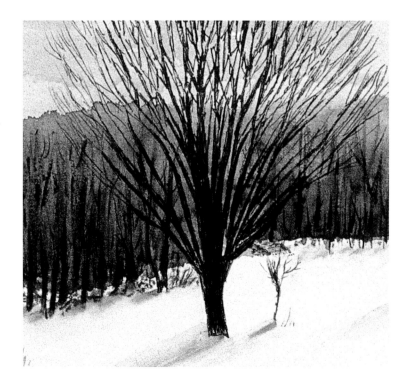

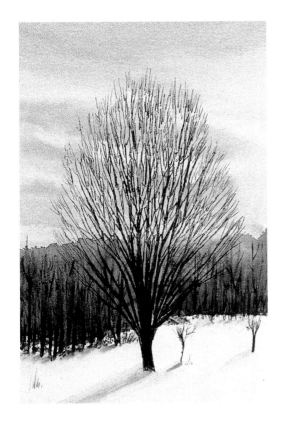

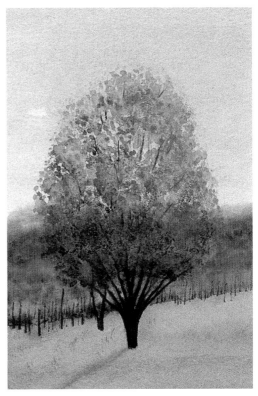

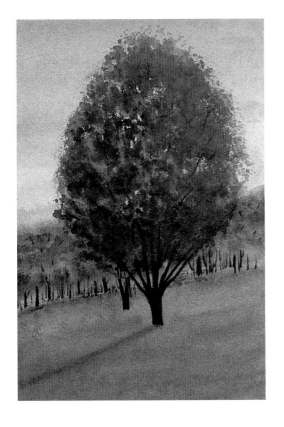

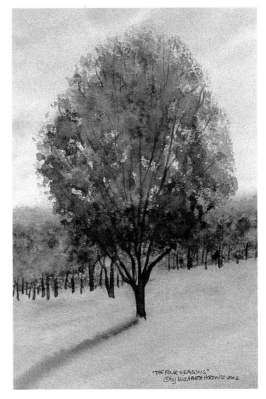

"THE FOUR SEASONS"
© by ELIZABETH HORONITZ · 2002

TIPS FOR COMPLETING SPRING TREE

- As you did for winter, paint the sky first—but the color here is a pale value of cerulean blue, painted in a graded wash.
- Paint the mountains as in winter, but alter the colors: bands of pale violet, pale Prussian blue, and pale Hooker's green with a touch of aureolin yellow. Make the green mountain band wider than the green band for the winter tree.
- Blot up the bands of paint in the tree trunk and let dry.
- Spring is infused with yellow. Underglaze foreground meadow with pale aureolin yellow, and when the shine has gone, add sap green and work down the paper. Keep the color pale; let it dry.
- With the "Dynamic Duo," paint distant trees, the pear tree trunk, and some of its limbs in a drybrush technique. Let it dry.
- To create clumps of foliage in spaces left among the branches, dip a dry sponge in pale aureolin yellow, and dab it on for the underneath layer. Let it dry.

- To build up foliage, mix two values of green: the lighter, sap green with aureolin; the darker, sap green with Prussian blue.
- Dip another piece of clean sponge into the lighter value of green and dab it on the clumps of foliage. Turn the sponge to alter the pattern.
- Be sure to leave sky holes for blue sky to peek through the foliage.
- Dip the sponge in the darker value of green and dab it sparingly at the bottom of foliage clumps to impart an illusion of volume and dimension. Let it dry.
- With darker value of green, paint a cast shadow from the tree's trunk to the lower left corner. Soften the shadow with a tissue.
- Add shadows to trees in the thicket, running in the same direction.
- As a final touch, with very little dark-value green on your sponge, make short, vertical strokes to add grass texture in the foreground.

TIPS FOR COMPLETING SUMMER TREE

- Paint the sky with cerulean blue with a dash of ultramarine blue for added intensity.
- Paint the mountains in pale violet, pale Prussian blue, and pale Hooker's green.
- Blot up color in the trunk and larger branches of the pear tree. Let it dry.
- Paint the tree trunk, limbs, and trees in the thicket with a drybrush technique, using the grayish "Dynamic Duo" mixture.
- Leave spaces among branches for the foliage to come. Let it dry.
- Paint the foreground meadow with a transparent glaze of Hooker's green. Let it dry. Add shrubs and foreground details. Let them dry.

- Sponge a lighter, diluted value of Hooker's green on the foliage. Let it dry.
- Sponge a darker value of green—Hooker's mixed with Prussian blue—on the foliage to add depth and dimension.
- With the darker value of Hooker's green, paint a cast shadow from the tree trunk to the lower left corner. Soften the shadow with a tissue.
- Use the same color to add shadows to trees in the thicket.
- With a sponge, add grass and shrubs to the foreground meadow in Hooker's green to complete your painting.

TIPS FOR COMPLETING AUTUMN TREE

- Paint a pale, neutral gray sky with a wash of burnt sienna with a dash of ultramarine blue.
- Mix pale violet with the sky color for the top of the mountains. Quickly mix a "Dynamic Duo" gray and dab it on the still-moist mountains and on some limbs and branches of the pear tree.
- For foliage, choose from yellows, oranges, reds, ochre, burnt umber, sepia (only three or four) and keep them pure and pale. Allow for sky holes. Blot up paint in the trunk and lower branches. Sponge on final touches of orange or red.

- Paint the foreground meadow with pale yellow ochre, pale burnt sienna, or very pale sepia. Let it dry.
- Paint the trunk and some branches of the pear tree with the "Dynamic Duo."
- Darken the left side of the trees with sepia.
- Paint the cast shadow of the tree with a pale yellow ochre mixed with a dab of sepia. Add foreground texture, using a slightly darker mixture of the autumn meadow color—and your four-seasons painting is complete. Congratulations!

Student Gallery: A TREE IN FOUR SEASONS

 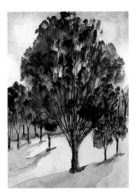 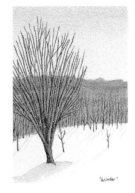 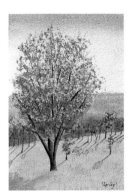

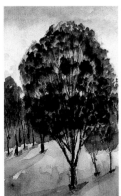

R. Mal Schwartz
FOUR SEASONS
Watercolor on paper, 22 × 15" (56 × 38 cm).

Sallie Smith
FOUR SEASONS
Watercolor on paper, 17 × 12" (43 × 31 cm).

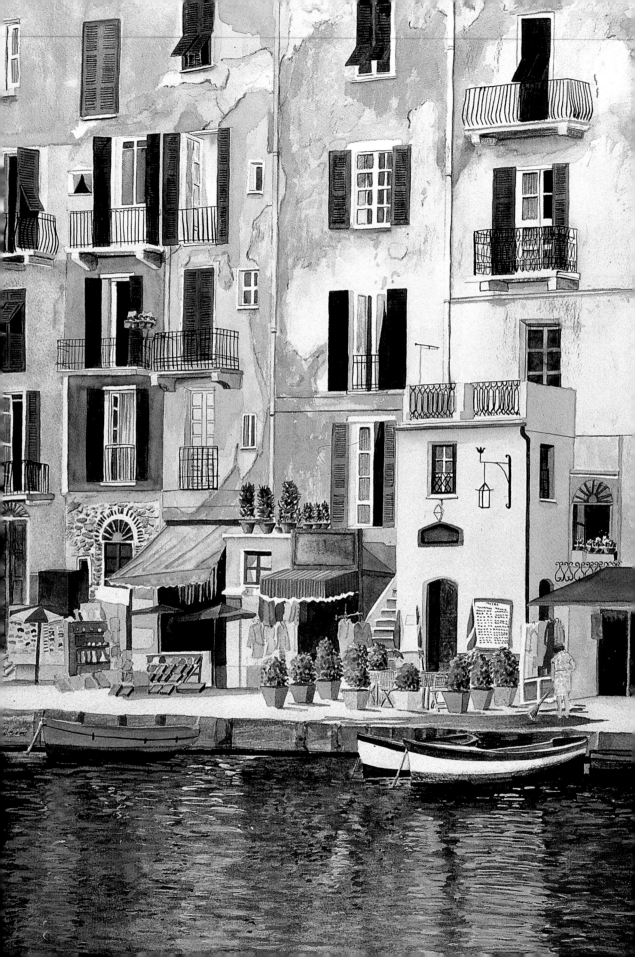

Water

Students in my classes frequently ask me how to paint water—yet many feel daunted by the prospect, even before they try it. But water and watercolor make great marriage partners. Both are aqueous, fluid, and may be spontaneous. Just as water seeks its own level, so will you in handling it. Cast aside your fear. Pretend you are jumping into a cool lake on a hot summer day, and just go with the flow! And when you do, the most important thing to remember: Paint water in a different technique from the one you use for sky or land in the same picture. For example: Contrast a wet-in-wet lake with a drybrush or graded sky above it.

Other important considerations are reflection, refraction, and surface patterns.

REFLECTION is water's ability to mirror colors and shapes from the sky, landscape, buildings, and other surrounding objects. Reflections in calm water are *not* distorted; they remain about the same shape and size of the objects being reflected; shapes *elongate* as the water becomes disturbed. Of course, images always appear upside down when reflected in water, and always directly below the image being reflected, regardless of the viewer's vantage point. Subtle value changes occur between an object and its reflection. Light areas are darker in value; dark areas, slightly lighter.

REFRACTION refers to a ray of light bending from a straight path due to a change in velocity from the air to water. The result is bouncing light on water making it glisten, twinkle, and "razzle-dazzle" the eye as the surface moves. Even a droplet of water such as a raindrop, dewdrop, or a teardrop has a refracted highlight.

SURFACE QUALITY describes the wave or ripple action that we see as patterns on a body of water. Never paint water with straight, flat strokes; use contour lines—fluid strokes that suggest the movement of the water. Those broken contour lines work like a venetian blind, alternately reflecting the sky and the surroundings. Use calligraphic strokes made with a round brush, alternating your brush pressure from light to heavy to light again.

Elizabeth Horowiz
LA SPEZIA, ITALY
Watercolor on paper,
32 × 28" (81 × 71 cm).

Drybrush technique can be used to simulate refraction—the sun's glints twinkling on the surface of water.

Water moves in patterns. The circular pattern on the left suggests a more tranquil surface than the squiggly pattern on the right, where winds or other action disturbed the water.

Practice making calligraphic strokes with a round brush that comes to a good point. On the background wash, note that ripples are smaller and paler in the distance; they grow darker and longer toward the foreground.

Left: This preliminary wash was too wet when painted over in a wet-in-wet technique, resulting in strokes that are too pale and almost lost. Center: These are the wiggle-squiggle calligraphic strokes that alternate like a venetian blind to capture the water and the object (or surrounding area) that it is reflecting. Right: This preliminary wash was too dry when the wiggle-squiggle strokes were painted over it. Hard edges formed; the edges should be soft.

To paint a raindrop or dewdrop on a leaf (from top): Draw a semicircle and add a highlight. Apply liquid mask to the highlight. Paint a dark stroke along the bottom edge. Rinse your brush and gradate the dark stroke up to the highlight. When dry, darken the bottom edge. Add leaf color. In this case, pale yellow-green shows the transparency of the water droplet on the leaf. After the paint dries, remove the liquid mask. Easy, yes!

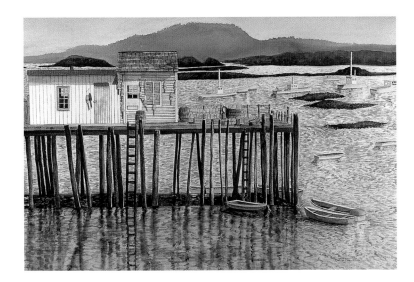

Elizabeth Horowitz
LOBSTER SHACK
Watercolor on paper,
30 × 40" (76x 101 cm).

*The first property of
water is reflection.*

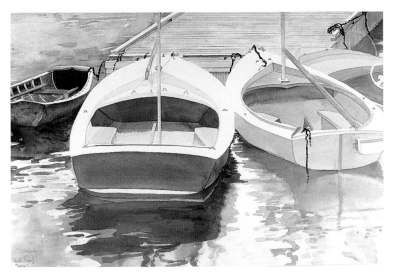

Elizabeth Horowitz
DOCKSIDE
Watercolor on paper,
30 × 40" (76x 101 cm).

*The second property of
water is refraction.*

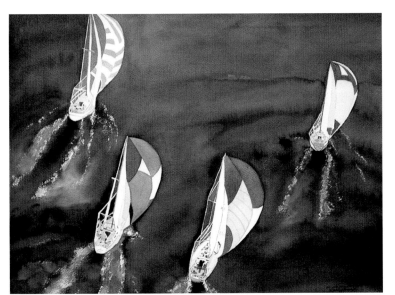

Elizabeth Horowitz
FOUR YACHTS RACING
Watercolor on paper,
22 × 30" (56 × 76 cm).

*The third property of
water is surface quality.*

Exercise: PAINTING A LAKE SCENE

STEP 1 Study this color photo taken at Lake Masten, in the Catskill Mountains of New York. The float is the focal point, but the goal is to capture the properties of water as morning light twinkles on the lake.

STEP 2 Use this black-and-white photocopy to guide you in making a value sketch of the scene in pencil on drawing paper. Later, when you begin to paint the scene, match your color values to this guide.

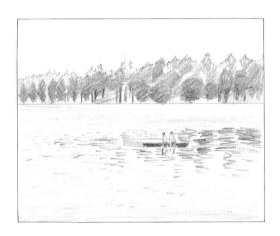

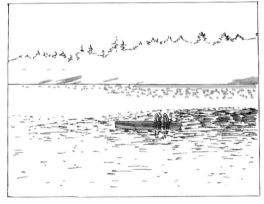

STEP 3 With a 2B pencil on sketch paper, create a five-tone value scale, the lightest being the white of the paper; then draw a rough value sketch of the scene. Use two or three values to suggest the mass of trees— darker at the shore line, lighter for the top trees reaching toward the sky. Indicate values on the water's surface, the darkest to represent tree reflections. Leave lots of paper unmarked as a reminder of where you'll be "holding the whites" for highlights.

STEP 4 Draw the scene lightly on watercolor paper. Be sure *not* to place the horizon line midway on your paper; put it above or below that point. Pencil an arrow at the upper-left corner as a reminder of the light source, which comes from behind trees on the left. Apply liquid mask to the brightest areas (shown in orange here). Brush it on in little strokes for highlights on the water near the far shore, and apply it to the entire float and ladder. Let it dry.

COLOR TIPS FOR COMPLETING YOUR PAINTING

- Sky: very pale value of cerulean or cobalt blue (mix large batch; also used for water)
- Distant trees: aureolin yellow, Hooker's green (mix two values or add Prussian blue to darken green) (mix large batch; also used for water)
- Distant shore: sap green or Hooker's green with yellow
- Lake: cerulean or cobalt blue—two values of whichever blue used for sky, so water reflects sky color
- Float: sepia (in two values)
- Feel free to choose other colors

PROCEDURAL TIPS FOR COMPLETING YOUR PAINTING

- Test your colors on scrap paper. In judging them, remember that watercolor dries one value lighter.
- Begin by painting the sky in a graded wash—darkest value at top, lightest where sky and trees meet—using a No. 6 round brush. The sky in the reference photo is extremely pale; make your sky bluer.
- Perhaps "pop out" a cloud before the sky dries completely. Blot the edges.
- Before the sky dries, stroke pale yellow at the top edge of the tree line for a backlit glow. Use a brush with a good point. Make calligraphic strokes that capture the look of pine trees.
- Using the lighter value of green, skip down and paint the sloping lawn on the left side of the distant shore.
- Keep using a calligraphic style that captures the individual silhouettes of different trees and allows the sky holes to be seen. Have fun with your brush!
- Add darker green to impart a three-dimensional feeling of mass to the trees.
- Add a few tree trunks and segmented branches, using dark sepia. Let it dry.
- Use pale sepia for the shoreline, a darker value where it hits the lake. Let it dry.
- Using the pale-blue sky color, paint the lake, working downward. Except for areas covered with liquid mask, the entire lake is now wet.
- Darken blue for a distant area of the lake; let it blend. Wait until the shine disappears.
- Here comes "Beat the Clock!" Timing is important, so work quickly while the paper remains moist and edges will be soft. Load a round brush with the darker blue (but still a light value), and paint short strokes with soft edges for far ripples; longer strokes for closer ripples.
- Using the lighter value of the tree greens on your damp paper, wiggle-squiggle your brush to create ripples near the float. Alter the pressure on your brush tip from light to heavy to light again.
- Use the two values of green for reflections that appear dark around the float; use the lighter value first. Leave the nearby "venetian blind" areas blue.
- Paint a few darker blue strokes for more reflections in the foreground. Blend these soft-edged strokes into the blue lake.
- When all your paint is dry, remove the liquid mask.
- Paint the sides of the float with sepia (or any color) in a drybrush or flat wash technique—the left side a bit lighter, consistent with the light source.
- Using the color for the sides of the float, paint the water below it. The ladder and its reflections may be a gray. The blue of the water should be sandwiched between the reflection colors of the float and ladder.
- Paint a dark value on the right sides of the ladder. The finishing touch: Leave a tiny, white highlight on the top where it bends and captures the light.

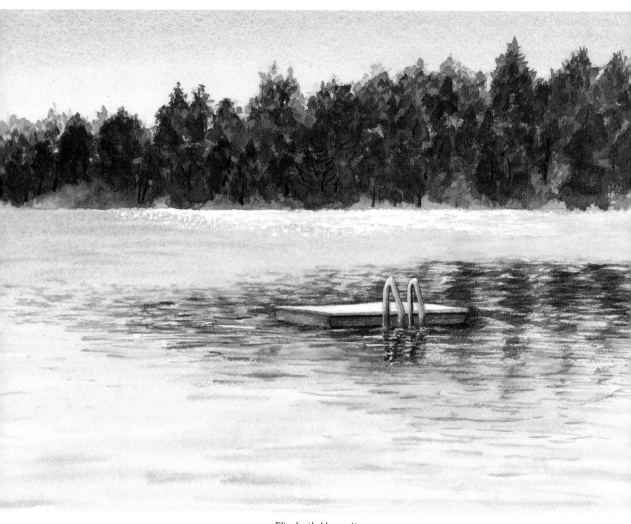

Elizabeth Horowitz
SUMMER MORNING
Watercolor on paper, 9 × 12″ (23 × 31 cm).

Student Gallery: A LAKE SCENE

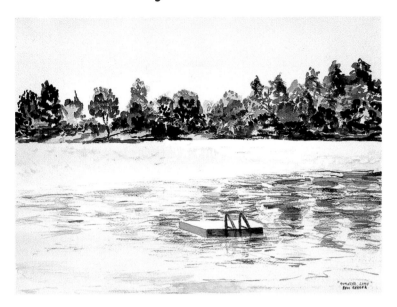

Reva Berger
MORNING LAKE
Watercolor on paper,
11 × 15″ (28 × 38 cm).

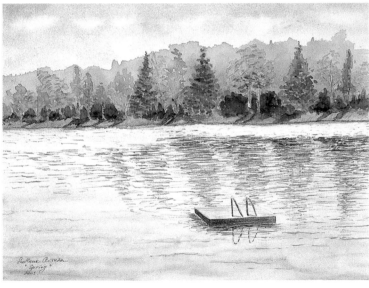

Svetlana Aniskina
SPRING
Watercolor on paper,
11 × 15″ (28 × 38 cm).

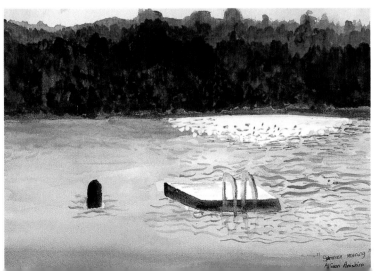

Allison Aniskina
SUMMER MORNING
Watercolor on paper,
9 × 12″ (25 × 31 cm).

113

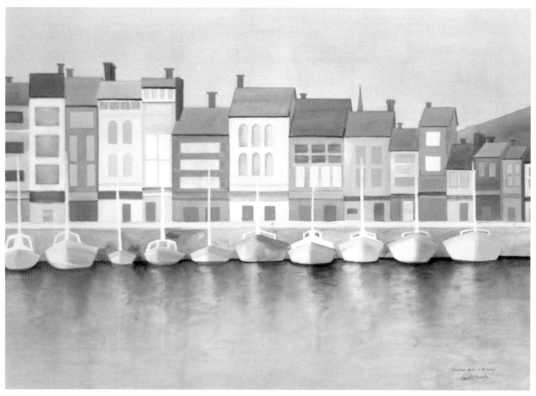

Elizabeth Horowitz
HONFLEUR HARBOR IN HARMONY
Watercolor on paper, 30 × 40" (76 × 101 cm).

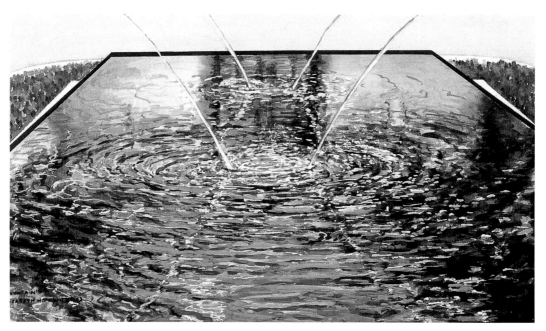

Elizabeth Horowitz
THE FOUNTAIN
Watercolor on paper, 15 × 22" (36 × 56 cm).

Elizabeth Horowitz
AT WATER'S EDGE
Watercolor on paper, 22 × 15″ (56 × 38 cm).

Flowers

To see how wonderful and varied portrayals of flowers can be, study the floral paintings of Georgia O'Keeffe and those of the Flemish masters Jan van Eyck and Rogier van der Weyden. And no chapter on the subject is complete without mentioning Henri Fantin-Latour, the nineteenth-century French master whose naturalistic representations took floral art to even more dazzling heights of beauty.

Flowers are a living subject that everyone responds to in positive ways. We all have personal preferences as to floral type, scent, color, and shape. Just as our responses to flowers are individual, so is the way artists portray them. Many adore painting flowers directly from nature, outdoors *en plein air* for greatest spontaneity and enjoyment. Some watercolorists work loose and painterly with vague definition. Others paint with great detail and botanical accuracy. Some work on a wet sheet of paper while others prefer a dry surface.

The goal of this chapter's exercise is to portray the essence of flowers in a representational way, using basic watercolor techniques. But the structure of the exercise, as in earlier pages, is open-ended, encouraging you to make your own compositional, color, and technique choices along the way in completing your painting. When you do, it's important to keep in mind the following fundamentals for painting flowers in watercolor.

Try to lead the viewer's eye around the painting with an active composition. One way to do that is by invoking the "odds are better than evens" formula: When deciding how many flowers to include, choose an odd number. Then differentiate the edges of each flower's petals by defining values from light to dark. Retain the white of the paper for white flowers, highlights, and pale shapes within the painting. If painting a vase on a table, don't place the vase or table's edge midway in your composition; place it off-center, not "smack dab" in the middle.

Elizabeth Horowitz
TULIPANO I
Watercolor on paper,
30 × 22" (76 × 56 cm).

Techniques for Painting Flowers

All the techniques covered in previous chapters apply to painting flowers. However, certain methods should be kept particularly in mind for florals.

WASHES Many artists begin by covering their paper with a background wash, or tint. Often it is variegated—a series of colors dropped in to blend and flow together. Another method is to sketch the flowers first, then flow the wash around them. Use blended washes on individual flowers as well. Paint a rose in one color, then use a different hue on its edges, dropped in for a variegated look.

GLAZING Glazing a wash over a previously dried wash imparts luminosity and produces a precise, unified combination of the two colors. For instance, to depict an orange flower, glaze over a yellow flower with red. Glazing can also make a flower seem to come forward or appear to be pushed back in the composition.

SOFT EDGES To soften hard edges, which form when a wash meets dry paper, use a stiff, damp brush, sponge, or tissue. Another way to soften floral edges: Paint the edge with clear water and the center with only slightly diluted pigment, then blend, producing a soft-edged flower.

BLEEDS OR COLOR RUNS Watercolor bleeds on wet paper. Sometimes that's desirable, but at other times, it isn't. To avoid bleeds in florals, leave white spaces around individual petals. Holding the white edges separates colors and keeps them from running together. That technique can produce a lovely painting style in itself.

POSITIVE AND NEGATIVE SHAPES Emphasize the contrasts of positive and negative shapes. Paint negative background shapes in a different value from the flowers. For example, with white daisies, add a dark value around the flowers.

FLORAL RIBS AND VEINS To create lighter floral ribs, paint the overall color of the petal first, then before it dries fully, dip a brush in clear water, blot it on a paper towel, and run it over the petal to form a streak of lighter value. To create darker ribs or veins, score a line with the back end of a brush on paper that is still wet. Paint will flow into the valley created by the score and appear darker in value. But note that once you score paper, you can't remove that crevice—so be sure to plan ahead when scoring.

SGRAFFITO From the Italian word for scratched, sgraffito is the last step in completing a painting: scratching away pigment to expose white paper where liquid mask wasn't used, perhaps to create flower pistils—or to remove paint that dropped on some areas. Scratch when the paint is almost dry. Since scratching abrades paper, paint can't be applied over it without looking messy.

IMPRESSING To suggest the papery texture of some flowers, press crumpled plastic wrap or paper towel on a wet wash of color. Put a heavy object on it (a book or paper weight) to hold it in place until it's dry. The crumples of the paper towel will reproduce its texture on the paint. This technique is unpredictable, so practice on scrap paper before applying it to your floral painting.

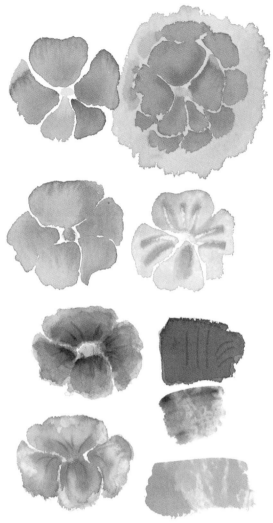

To paint a variegated wash: Sketch a flower and cover it with liquid mask. After the mask dries, moisten the background with clear water and drop in a variety of colors and let them bleed and flow together. When the colors are completely dry, remove the mask.

To lift color with an underglaze: TOP LEFT: *Draw and paint a leaf with aureolin yellow (or other nonstaining color) as an underglaze. Let it dry.* TOP RIGHT: *Glaze over it with Hooker's green (also a nonstaining color).* BOTTOM LEFT: *Before the green is dry, take a clean brush, dip it in water, and pat on a towel, then drag it over areas to be lifted as veins. Rinse, pat the brush, and repeat until the veins are all in place.* BOTTOM RIGHT: *Add a darker value of green to some areas for variety and a more realistic look.*

Special tricks and brushwork that watercolorists call on particularly when painting flowers are: TOP ROW, LEFT: *Bleed/Color Runs: The yellow center bled, or ran into, the pink because both were wet.* TOP ROW, RIGHT: *Glazing: The light color was glazed, or painted over, a dry, darker layer to unify it.* SECOND ROW DOWN: *Scratching/Sgrafitto: An example of how a dull knife scratched out some color when the paint was almost dry.* THIRD ROW DOWN: *Scoring: While the paint was still very wet, I used the back end of a brush to score the paper for linear details. Color then ran into the scores, creating a darker value.* BOTTOM ROW: *Impressing: I pressed a paper towel on the painted flower to give it more delicacy.*

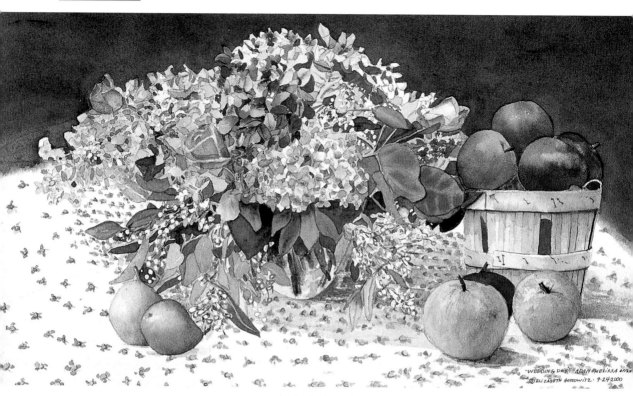

Elizabeth Horowitz
WEDDING BOUQUET
Watercolor on paper, 15 × 22" (38 × 56 cm).

The strong contrast between foreground and background values strengthens this painting and leads the viewer directly to its focal point: the light, freshly colored floral arrangement.

Elizabeth Horowitz
HYDRANGEAS
Watercolor on paper,
30 × 40" (76 × 101 cm).

Shadows can carry as much weight in a composition as the objects themselves, becoming an integral part of the painting. Keeping shadows consistent with the light source can produce dramatic effects.

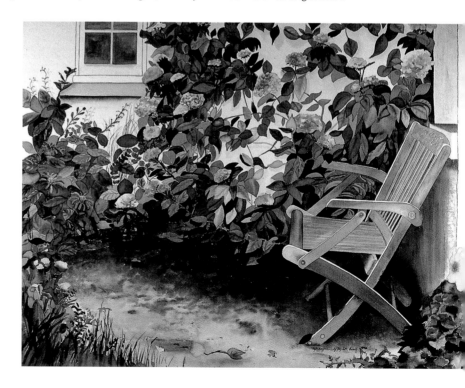

120

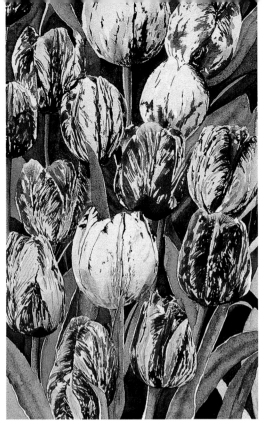

Elizabeth Horowitz
REMBRANDT TULIPS
Watercolor on paper, 30 × 22" (76 × 56 cm).

When you fill an entire composition with flowers, take them to the paper's edges, letting some spill right off the sides.

TIPS ABOUT FLOWER SHAPES

Flowers fall into various shape categories. When painting a mixed bouquet, choose blossoms of different shapes for a very lively look. A few examples of each shape category include:

- Bells: campanula, chinese lantern, lily of the valley
- Trumpets: columbine, daffodil, jonquil, lily, narcissus
- Lipped/bearded: honeysuckle, iris, nasturtium, wisteria
- Stars: hibiscus, periwinkle, primrose, violet
- Rays/pompoms: chrysanthemum, daisy, dahlia, geranium, marigold
- Cups/bowls: camelia, crocus, peony, poppy, tulip
- Multiheaded: hyacinth, lilac, rhododendron
- Spikes: delphinium, foxglove, grape hyacinth, hollyhock

TIPS ABOUT GREENS

- Always use two or three greens to describe the leaves and stems in a floral painting. Using only one green is bor-r-r-ing.
- Avoid using greens directly from the tube. The look shouts "Amateur!" Add a touch of another color to any tube green.
- Most greens can be mixed by combining different yellows and blues.
- Olive green is a warmed hue that can be mixed by adding alizarin crimson to sap or Hooker's green.
- Viridian green used alone can have a dye quality, yet, mixed with other colors can produce exquisite hues. Experiment by adding to it either aureolin yellow, gamboge, alizarin, ultramarine or Prussian blue, raw or burnt sienna.
- Vary green values by adding more or less water.
- Vary color temperature by adding more yellow or red for a warmer green; more blue for a cooler green.
- Mix lush greens on your paper, rather than over-mixing on your palette.
- To add texture to a green, reach for a granular color such as cerulean, manganese, or ultramarine blue or raw sienna.
- Experiment with various oranges and yellows mixed with different blues to produce a variety of greens. To avoid a muddy look, as a general rule, it's best to blend only two colors.
- As you work, always make color notes for future paintings.

Exercise: PAINTING HOLLYHOCKS

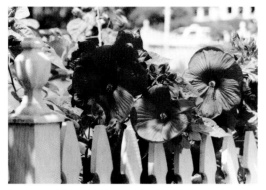

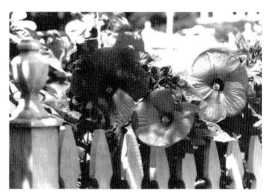

STEP 1 Study this reference photo of holly-hocks. Where are the darkest values? Where are the lightest? The lightest areas are places to keep paint-free. Let the white of the paper represent those brightest parts of your picture.

STEP 2 This photocopy of the color photo reveals more clearly the range of values. If working from a color photo, make an enlarged, black-and-white photocopy as a value aid.

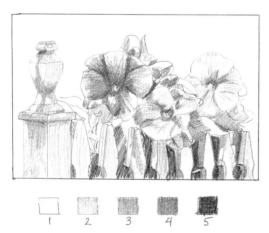

STEP 3 Make a value pencil sketch on drawing paper, using the black-and-white reference photo as a guide. Key the values from one (lightest, paper white) to five (darkest). This sketch makes it easier to match the values in paint.

STEP 4 With your 2B pencil, lightly draw the scene on watercolor paper. Begin by ruling in the post and the fence, then add the flowers. Edit out the blurry background details and eliminate most of the leaves above the flowers so the top edges of the blossoms silhouette against the sky. Draw the three central holly-hocks. If you add more, keep to an odd, rather than even, number. Apply liquid mask to hold the white for brightest highlights on the fence, flowers, and their centers for stamen and pistil details. Don't mask the light-pink petals; those should be washed with pale-pink paint. Place an arrow in the upper-left corner as a reminder of the light source while painting. Let the mask dry thoroughly.

COLOR TIPS FOR COMPLETING YOUR PAINTING

- Sky: ultramarine and cerulean blue
- Fence: ultramarine blue and burnt sienna (my "Dynamic Duo")
- Flower petals: magenta, alizarin crimson, cadmium red, phthalo blue, sepia, violet
- Stamen, pistils: aureolin yellow, cadmium red
- Leaves: Hooker's green, sap green, aureolin yellow, ultramarine blue, Prussian blue, alizarin crimson

PROCEDURAL TIPS FOR COMPLETING YOUR PAINTING

- Use a graded wash or wet-in-wet technique to paint in the background sky with an intense blue (ultramarine or cerulean). Let it dry thoroughly.
- Use a drybrush technique for the texture of weathered wood on the fence, painted in a mix of burnt sienna and ultramarine blue. Mix two batches: one with more burnt sienna for the warm side of the fence; the other, for the cool shadow side, should favor the blue.
- If the "Dynamic Duo" isn't dark enough, build it up by letting one coat dry, then go over it with the same mixture until you reach the correct value.
- For the blossoms, mix magenta or pale alizarin crimson into three values, squirting water to form three piles—the lightest value, very pale.
- Lay in lightest values first, give them time to dry; work on one petal at a time. Give each petal a light and a darker side for edge definition.
- Don't paint all the petals of one flower at once; skip around to allow drying time so the edges won't bleed.
- Use a barely diluted magenta to paint the petals' ribs; soften them with a brush of clear water. If you prefer, use the scoring method instead.
- For the darkest petal values, glaze violet over the magenta. to produce violet. Add sepia if needed.
- Work from the center of the flower out.
- Perhaps add a touch of sepia to darken the magenta-violet mixture further.
- Work wet-in-wet, adding more pigment to achieve the correct value. Let it dry.
- Remove liquid mask from the flowers. Paint their centers, stamens, and pistils yellow. Add a touch of cadmium red to deepen the value of the centers.
- For leaves, mix sap green and Hooker's green—a lighter and darker value of each. Dab two more piles of sap and Hooker's green on your palette; add yellow to one pile, add blue to the other. Now you have six greens.
- Mix one more batch of sap green with its complement, alizarin crimson, to create a neutral olive green. Neutrals add power to florals.
- Paint the leaves by skipping around your paper. If the edges dry without touching, they will be sharp.
- Work light to dark, painting the yellow-green leaves first in the top-left area where the sun hits them.
- Paint the darker, cooler, bluish green leaves close to the fence. Blend clear water on some leaves to create soft edges for contrast.
- Glaze over some darker leaves with Prussian blue to make them appear to recede. Add sepia to darken them further if needed.
- Remove remaining liquid mask and blend hard edges with a stiff, wet brush.
- Sign your painting in the lower-right corner, allowing space for a mat and frame—and smile! You have completed a very challenging painting!

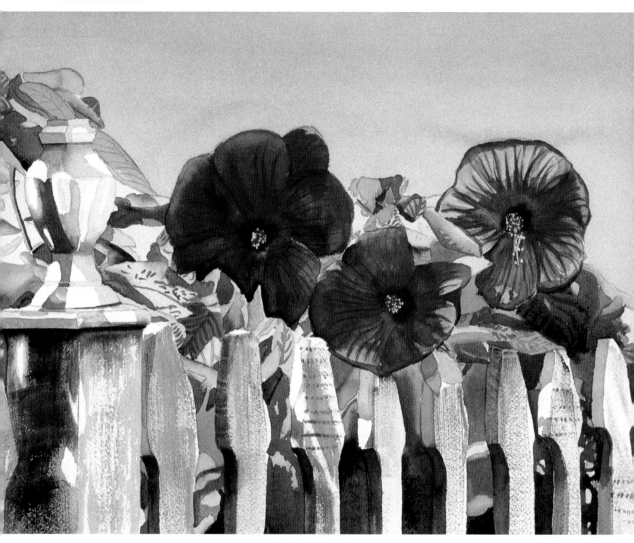

Elizabeth Horowitz
THE AMERICAN DREAM
Watercolor on paper, 12 × 16" (31 × 41 cm).

Student Gallery: PAINTING HOLLYHOCKS

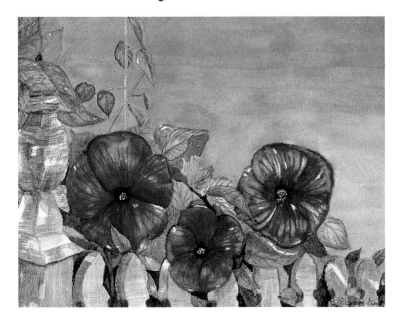

Jill Vondervor Frank
HOLLYHOCKS
Watercolor on paper,
9 × 12″ (23 × 31 cm).

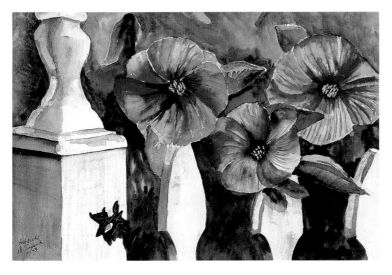

R. Mal Schwartz
HOLLYHOCKS
Watercolor on paper,
15 × 22″ (38 × 56 cm).

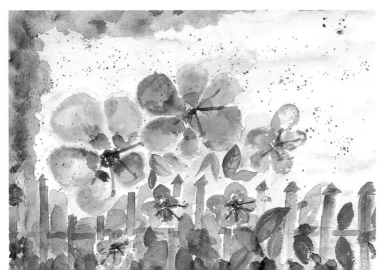

Leslie Klepner
PINK FLOWERS
Watercolor on paper,
11 × 15″ (28 × 38 cm).

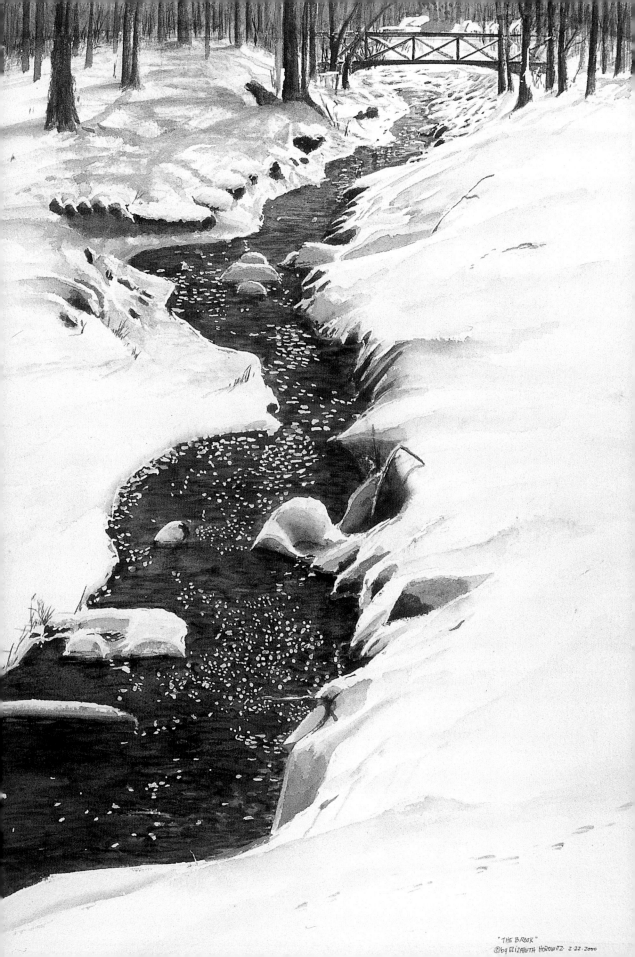

"THE BROOK"
©by ELIZABETH HOROWITZ· 2·22·2000

Winter Landscape

When the world turns white with snow, the visual landscape is reduced to simple elements of line, shape, and value. Watercolor snowscapes are discerned more by value and shape than by color. Sunlight may be weaker in winter, but it casts the longest shadows, offering great contrasts between their dark value and the whiteness of snow.

A winter scene can depict a snowstorm in full force—or after the snow has fallen, with bright sunshine making things look linear and black and white.

Another dramatic dimension is added when snow is painted at twilight or illuminated by moonlight.

During a snowfall, the sky takes on a pale, cold, gray tone. The landscape is a muted gradation of values from white to gray to black. After a snow storm, the sky turns a brilliant blue, a painter's dream. Snow covers objects like confectioner's sugar or cake frosting. Sun glints dance on its surface. Snow at twilight takes on a violet-blue cast. Whatever illumination exists glows yellow or orange with a halo, such as would come from a street light or light from within a house. Violet shadows and yellow lights are complementary colors that flaunt and intensify each other, making snow scenes at dusk so eye-catching. The shadows are subtle exaggerations of the objects casting shadows. Shadows always have soft edges on snow. To watercolorists, winter light on snow is all about cool and warm color. In fact, snow is never really all white, since cast shadows and reflected light affect its coloration so powerfully. As a watercolorist, you have a head-start by using the white of the paper to represent a blanket of snow—then, when you drop in cool blues/violets and warm yellows/oranges, you enrich a winter scene and are on your way to creating an accomplished work of art.

Elizabeth Horowitz
THE BROOK
Watercolor on paper,
26 × 18″ (66 × 46 cm).

Exercise: PAINTING A SNOW SCENE

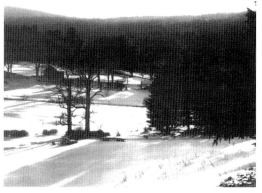

STEP 1 Using this color photo as reference, your goal is to evoke the sense of a snow scene at dusk while planning the whites of the paper and consciously playing warm and cool colors against each other. Since my photo doesn't show colors clearly, use your artist's imagination to fill in what my camera missed.

STEP 2 Study the black-and-white photocopy of the color snapshot. Although it's murky, it emphasizes the dark-to-light values that make up the picture. Once more, I recommend that whenever you use a color photo as reference, convert it to an enlarged, black-and-white photocopy as an added tool.

STEP 3 In pencil, create a five-value sketch on drawing paper, based on the black-and-white reference photo. Make a box at the bottom for each of the five values, from lightest (the paper white) to darkest. Then make notes on your sketch indicating where each value is located. An arrow at upper right indicates light source.

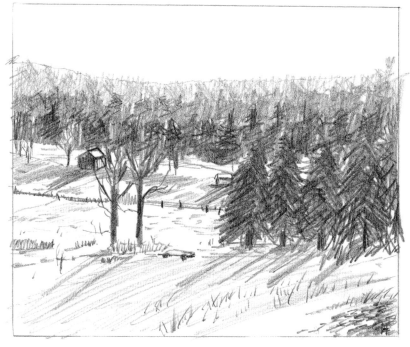

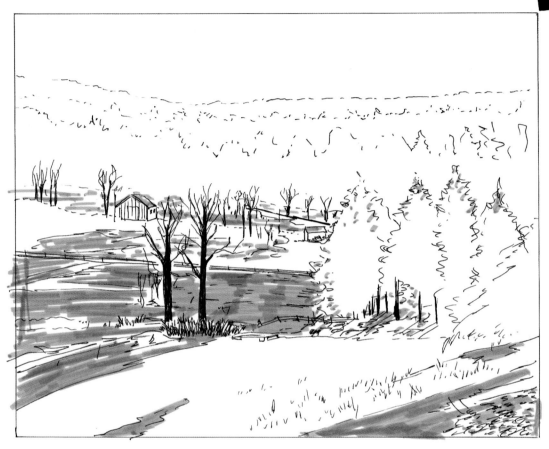

STEP 4 With your 2B pencil, make a light line drawing of the snow scene on watercolor paper. Place an arrow at the upper-right corner as a reminder of the light source while painting. Observe that all the shadows are on a diagonal. Apply liquid mask to all areas that will remain white. Don't overlook the white roofs on the two barns in the distance. Let the liquid mask dry.

COLOR TIPS FOR COMPLETING YOUR PAINTING

- Sky: pale blend of "Dynamic Duo," burnt sienna and ultramarine blue
- Distant mountains: pale aureolin yellow; pale Hooker's green with dab of alizarin (produces olive green); Hooker's green with dab of Prussian blue; Hooker's green with Prussian blue mixed to dark value
- Tree trunks: "Dynamic Duo," burnt sienna and ultramarine blue
- Barns: cadmium red with dab of sepia
- Barn shadows: Prussian blue over magenta to produce violet; sepia
- Foreground evergreens: Hooker's green, Prussian blue, sepia
- Distant road and fence: sepia, "Dynamic Duo," burnt sienna and ultramarine blue
- Sun on snow: pale aureolin yellow

PROCEDURAL TIPS FOR COMPLETING YOUR PAINTING

- Paint the sky first. For this nearly white winter sky, use a very pale value of bluish-gray "Dynamic Duo." Test it on scrap paper until it's light enough.

- For distant mountains, paint pale yellow across the top to suggest the backlit glow of setting sun. Where treetops meet sky, dab strokes with a pointed round brush held parallel to the paper to create the uneven look of a tree line.

- Paint the olive green blend into some of the yellow area.

- Working down the distant mountain range, paint Hooker's green with Prussian blue to create a second mountain ridge.

- Complete the mountains with the darkest value of green, working downward to where trees meet snow.

- Paint the distant tree trunks with vertical strokes of sepia or the "Dynamic Duo." Score some trunks and let them blend into the distant mountain range.

- With less pressure on your brush, make the top branches finer as they reach upward, but don't make them too wispy.

- Are tree trunks a dark value? If not, paint them again, using a drybrush technique.

- Although the barns' color can't be seen in my photo, paint them barn red—cadmium red with a touch of sepia. Leave the roofs white to appear covered with snow.

- When dry, apply a violet glaze to the shadow side of the barns.

- Paint a sepia shadow under the eaves of both roofs, and add barn details such as windows and doors.

- Paint the little hay wagon in the foreground red.

- For the evergreens at right, use Hooker's green with Prussian blue, and olive green (Hooker's with alizarin). Although not too visible in the reference photo, leave some air holes in the trees to reveal light coming through here and there.

- Use burnt sienna for the evergreen tree trunks, underbrush, and foreground weeds poking up all around through the snow.

- Use sepia on the distant road, fence, and snow-covered rocks in a drybrush technique.

- Use pale ultramarine blue for cast shadows on the snow, all running on a diagonal.

- Do you want footprints in the snow? Place drops of clear water in a footpath pattern and drop in bits of pale blue or violet.

- Darken the shadows to the left of the larger barn. Follow the light source as you add shadows being cast from the trees and fence. Let it all dry well.

- Remove all liquid mask. Add a teeny bit of pale yellow to the snow for a sunlit glow. Keep it subtle. Be sure some snowy areas remain white.

- Sign your painting in the lower-right corner, leaving room for a mat and frame. Step back and admire your work. If it looks like winter, congratulate yourself on a job well done.

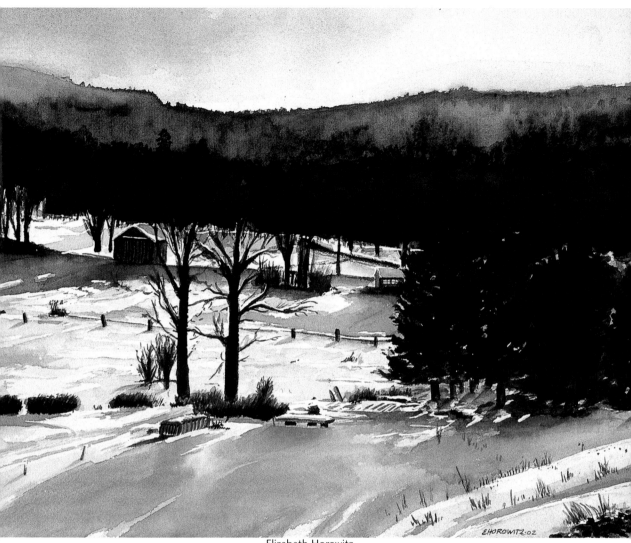

Elizabeth Horowitz
WINTER CRISP
Watercolor on paper, 12 × 16″ (31 × 41 cm).

Student Gallery: A SNOW SCENE

Audrey Bartner
BLUE SHADOWS
Watercolor on paper,
11 × 13" (28 × 33 cm).

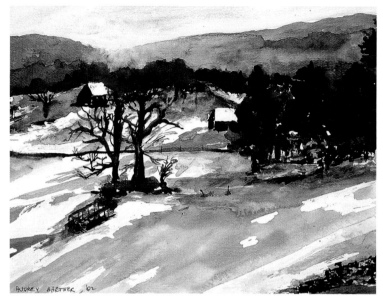

Lora Cooper
CONNECTICUT SUNRISE
Watercolor on paper,
11 × 15" (28 × 38 cm).

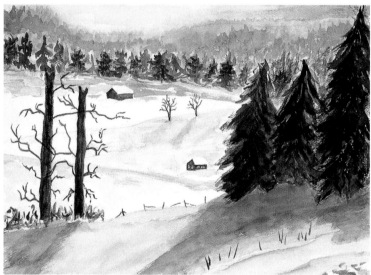

Ilene Oppenheimer
WINTER MORNING
Watercolor on paper,
10 × 16" (25 × 41 cm).

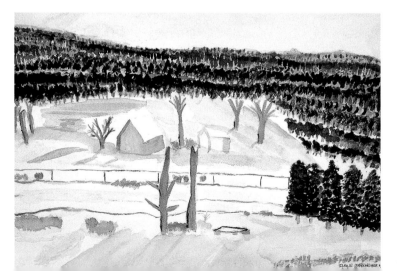

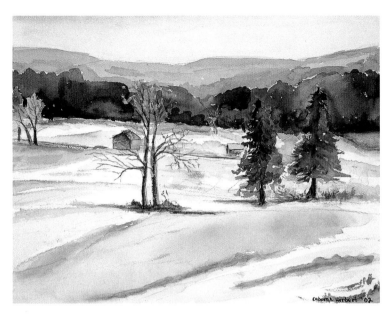

Deborah Herbert
WINTER TWILIGHT
Watercolor on paper,
12 × 16″ (31 × 41 cm).

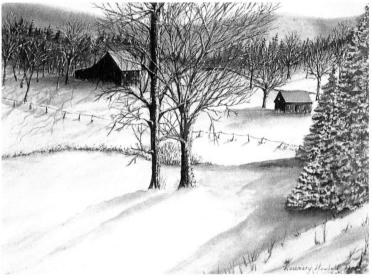

Rosemary Howlett
GOLDEN HOUR
Watercolor on paper,
11 × 14″ (28 × 36 cm).

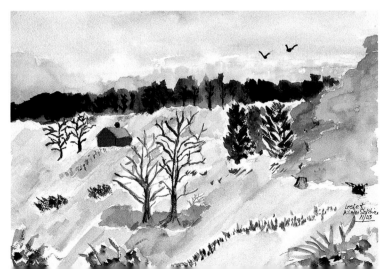

Leslie Klepner
WINTER SOLSTICE
Watercolor on paper,
10 × 14″ (28 × 36 cm).

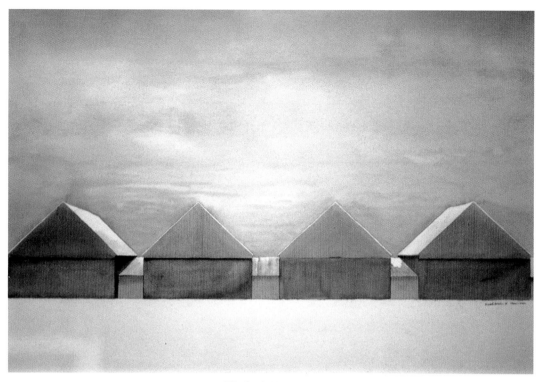

Elizabeth Horowitz
FOUR BARNS IN WINTER
Watercolor on paper, 30 × 40" (76 × 101 cm).

Skies set the tone and atmosphere. A wet-in-wet sky that shows cool grays can evoke an approaching snowstorm.

A little trick for remembering how to express atmospheric perspective in watercolor is to think of "purple mountain majesties"—that wonderfully descriptive lyric in America the Beautiful. *As mountains and other elements recede into the distance, they appear to be violet-blue, smaller, less focused, and with softer edges.*

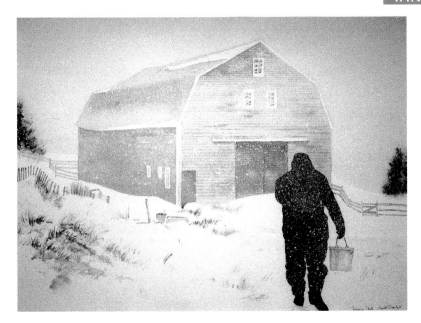

Elizabeth Horowitz
DECEMBER DAY
Watercolor on paper,
28 × 32" (71 × 13 cm).

Can you feel the blizzard facing this dairy farmer? Atmospheric perspective, which makes things get paler as they recede, is accentuated by the gradations of values toward the distance.

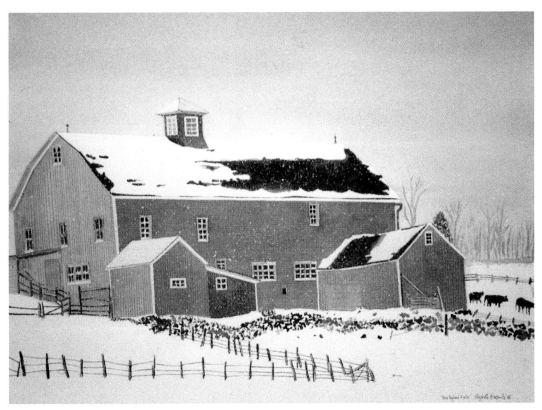

Elizabeth Horowitz
NEW ENGLAND WINTER
Watercolor on paper, 28 × 32" (71 × 13 cm).

Snow accentuates the linear, graphic quality of a scene. Plan the whites of your paper so your composition is abstractly interesting.

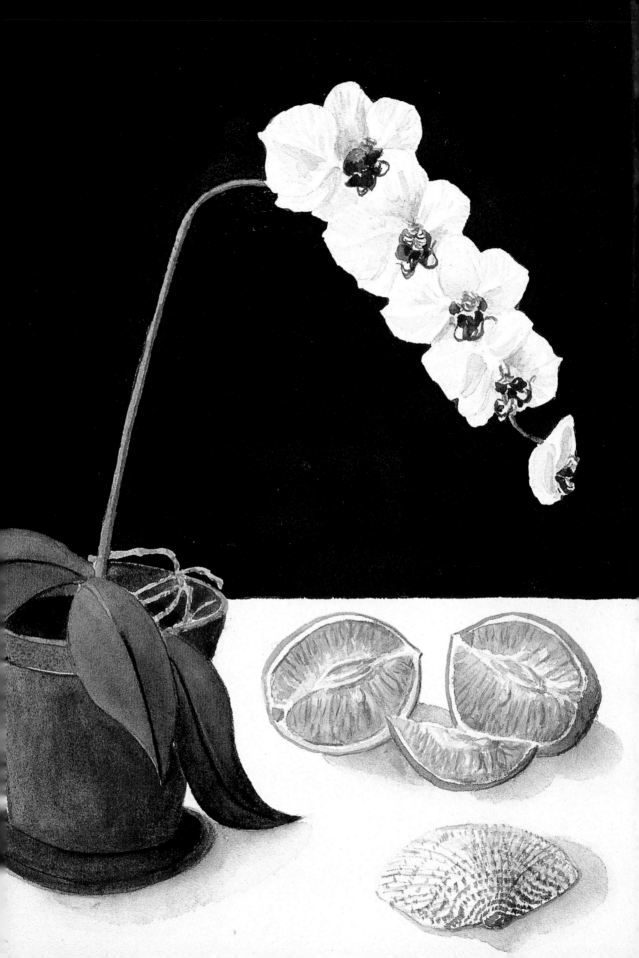

Still Life

Whenever you're stalled because you don't know what to paint, just look around you at your art supplies, and you'll find a wealth of objects to arrange into an exciting still life.

To give still life extra punch, professional illustrators often use pen and ink with watercolor. The combination produces a strong, graphic quality, varied textures, subtle gradations in value, and rich darks. That's the focus of this final chapter.

So, in addition to working with watercolor, include touches of black ink in the exercise ahead. Be sure that your drawing pen has indelible, waterproof ink in it so your ink strokes won't be disturbed if your wet brush or a watercolor wash touch them.

Begin by gathering your watercolor supplies into an interesting still-life arrangement—using an odd number of objects, not an even number. Include your favorite colors of paint tubes, a selection of brushes, a water container, your palette, a sponge, paper towels, pencils, and so on. Perhaps bring in a corner of a painting in progress. Think of using diagonals in arranging items; avoid lining them up right next to each other in straight lines. On the other hand, instead of carefully placing the objects, perhaps simply grab a few tubes of paint and just drop them. Let them fall where they may. Building a still life on that random pile may produce the most unusual and spontaneous arrangement of all.

Try to work from an unusual vantage point, rather than drawing a head-on arrangement. For instance, consider looking down on the setup as you paint or view it from an oblique corner angle. But whichever setup you choose, light it so that some of the objects cast interesting shadows—and you're ready to go!

Elizabeth Horowitz
TROPICAL TREASURES
Watercolor on paper,
12 × 9″ (33 × 23 cm).

Studio Still Life

Having graduated from beginner by completing all the exercises up to this chapter, now you can manage the opening steps of this exercise quite confidently without having to refer to preliminary illustrations that accompanied all the previous studies. Just review the following reminders as you proceed. On the pages ahead, when you see the final "Student Gallery," it will be interesting to note how ordinary art supplies can inspire a wide variety of appealing still-life watercolor paintings. (My own large study, *The Artist's Table*, is in the front of the book, on page 10.)

When you finish your final painting and close these pages for now, I hope you will return to them often as a refresher course, as you continue to build these fundamental skills as a watercolorist.

TIPS FOR COMPLETING YOUR STUDIO STILL LIFE

- With your 2B pencil, lightly sketch the arrangement of your art supplies on watercolor paper.
- Perhaps add a pattern to the table surface or to the background.
- Put the horizon line (table edge) above or below the paper's midway point.
- If the table has a straight edge, apply masking tape to it and paint in the background first before applying any liquid mask.
- Apply liquid mask for highlights, such as the shine in a water container.
- Let the liquid mask dry completely.
- Paint the background first, using a technique and value that will contrast with the rest of the composition. Let the background dry.
- Paint cast shadows and shadows on the objects with a neutral gray. Soften their edges with a clean, thirsty brush. Let the shadows dry.
- Paint pale colors first. Work from light to dark, adding color wherever you see it. Try to be calligraphic with your brush to create interesting strokes. Let it dry.
- Remove the liquid mask. Run your hand over the paper to be sure it's all gone.
- Paint in areas that were masked off. Leave the highlights white.
- Work in black, waterproof ink to add lettering on paint tubes, darker values, textures, to emphasize certain objects with ink outlines, and so on.
- Sign your painting in the lower-right corner, allowing for a mat and frame. If you have completed all the exercises in this book, you are no longer a beginner. This is graduation. Congratulations!

Student Gallery: STUDIO STILL LIFE

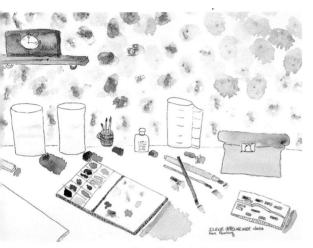

Ilene Oppenheimer
FUN PAINTING
Watercolor on paper, 10 × 14″ (25 × 36 cm).

Reva Berger
ARTIST'S TABLE
Watercolor on paper, 7 × 11″ (17 × 28 cm).

Carola McAndrew
ARTIST'S TOOLS
Watercolor on paper, 11 × 8″ (28 × 20 cm).

Sallie Smith
WATERCOLOR SUPPLIES
Watercolor on paper, 12 × 14″ (31 × 36 cm).

Student Gallery: STUDIO STILL LIFE

Carolyn Nelson
ARTIST'S TOOLS
Watercolor on paper,
12 × 16″ (31 × 41 cm).

Svetlana Aniskina
ART WORK
Watercolor on paper,
10 × 14″ (25 × 36 cm).

Allison Aniskina
M&M'S
Watercolor on paper,
10 × 14″ (25 × 36 cm).

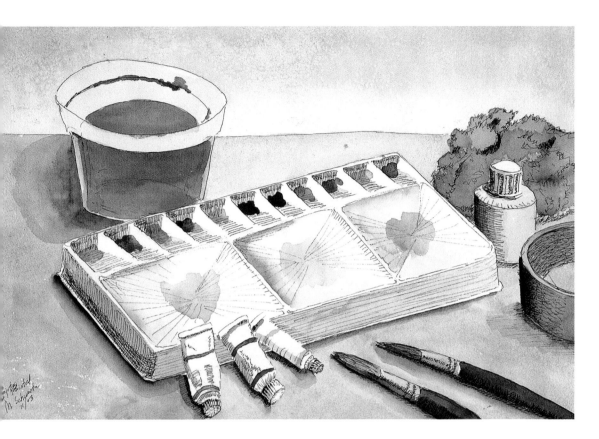

ABOVE: R. Mal Schwartz
**THE PAINTING THAT
I PAINTED**
Watercolor on paper,
15 × 22" (38 × 56 cm).

LEFT: KathleenFitzgerald
ON MY TABLE
Watercolor on paper,
12 × 16" (31 × 41 cm).

Elizabeth Horowitz
PEGGY'S BREAKFAST
Watercolor on paper, 26 × 32″ (66 × 33 cm).

Just as studio supplies can inspire a painting, so can everyday food items on a breakfast tray. An overhead angle, slanted tabletop, and textured cloth all contribute to turning a simple subject into an appetizing still life.

Index

Elizabeth Horowitz
CASTELLA DA VOLPAIA, ITALY
Watercolor on paper, 22 × 30″ (56 × 76 cm).